CHURCHES OF CAMBRIDGESHIRE

JOHN E. VIGAR

AMBERLEY

This edition first published 2023

Amberley Publishing
The Hill, Stroud
Gloucestershire GL5 4EP

www.amberley-books.com

British Library Cataloguing in Publication Data.
A catalogue record for this book is available from the British Library.

ISBN 978 1 3981 1459 3 (print)
ISBN 978 1 3981 1460 9 (ebook)

Typesetting by SJmagic DESIGN SERVICES, India.
Printed in Great Britain.

CONTENTS

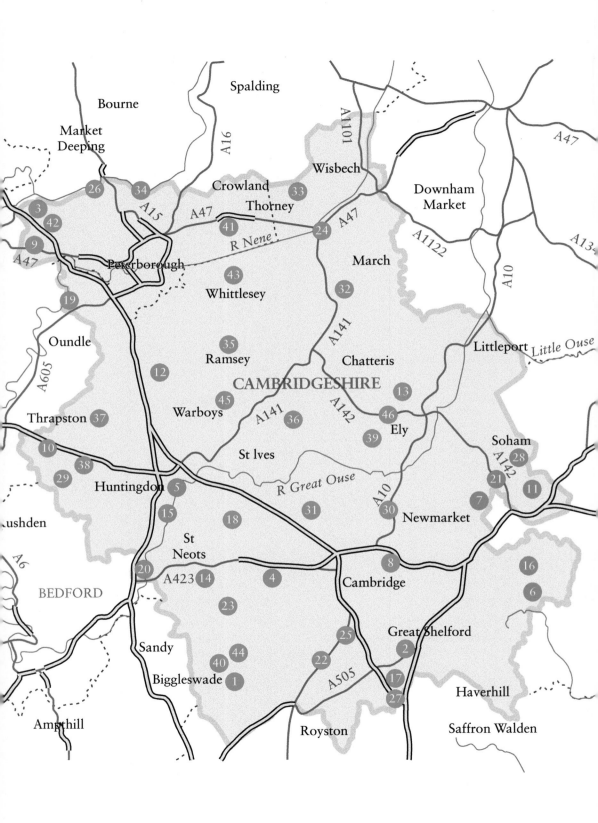

INTRODUCTION

As a county Cambridgeshire is hard to define, having been artificially formed by the amalgamation of several previously independent historic areas, each with its own character. Its diverse geology includes some of the best building stone in England, and some of the worst, as well as areas that have no native building stone at all. Parts of it were once managed by the Crowns of both England and Scotland and much of it was held by monasteries and Cambridge Colleges where the wealth of those institutions can easily be identified in its buildings. Yet it still has areas where wealth never reached and where the architecture is pedestrian as a result.

There is a proud early history of Christianity here. St Felix of Burgundy arrived at Soham and founded a monastery in AD 630 and later in the century monasteries were established at Peterborough and Ely. Following Danish raids in the ninth century new churches were established and old ones renewed until, after the Norman Conquest, there was an explosion of church building, in the form of dozens of new monasteries and parish churches, with most of the latter remaining in use today.

In a book whose brief covers fewer than fifty parish churches it has not been possible to create a comprehensive guide, but I have tried to include something from each period of architecture, drawn from a selection of churches both famous and little-known. I have long been a champion of those buildings which are hardly known for the very reason that few visit them. They are just as interesting and important as the better-known churches, and they deserve our support. The majority of churches in this book are open daily and the few that aren't still welcome visitors by keyholder or arrangement.

1. Abington Pigotts, St Michael

This church is largely unknown, except amongst the cognoscenti who come here to explore the myriad of clues it offers. It is set away from its village, but close to the site of its medieval rectory which was replaced in the Georgian period. Amazingly the Pigott family were patrons, and often rectors, of the church for nearly 500 years, and their presence can be found all over the building. St Michael's is a very simple late medieval building, the only reminder of something older being the scar on the west wall over the arch into the tower which represents a lower, more steeply pitched roof. To either side of the tower arch are little windows, or hagioscopes, to allow a bellringer a view of the altar to enable him to ring the bell at the Consecration. It shows us that, at that time, the bell ropes hung against the north and south walls of the tower, rather than in the centre.

Nearby is a very crude and early chest, probably not originally made for the church as they usually have three locks (for the churchwardens and incumbent) and certainly don't usually have carrying handles! High above the tower arch is

a funeral hatchment carried at the funeral of Mary Graham-Foster-Pigott who died in 1858. It is easy to see the pickaxes of the Pigott family together with a rather grisly crowned human heart. The tower arch, like most dressed stone in the church, is covered in graffiti dating from the medieval period from the intertwined double MMs representing Our Lady to more secular names, initials and dates. There are some sturdy fifteenth-century benches in the nave and a pulpit made up of Flemish carvings, and eighteenth-century panelling. Above the pulpit the upper door that led to the rood loft is obvious, its staircase having been created by infilling the north-east corner of the nave. Crudely set into the chancel arch is the fifteenth-century screen which must once have been set further west – see the damaged capital on the south side of the chancel arch. The tracery lights of the nave contain some restored medieval angels including one cheeky-looking cherubim standing on a wheel and with a liberal sprinkling of eyes across his wings and body. Take binoculars to see them.

Two memorials caught my eye. In the chancel that to Mary Pigott who died in 1816 is by the celebrated sculptor John Bacon Junior. It's signed in the bottom right-hand corner and shows a portrait medallion with a background of a weeping willow tree – a popular symbol of mourning. The other is to Elizabeth de Courcy Ireland who died in 1937. Born a Pigott, her epitaph says that she was 'called to the higher life, beyond the veil', reminding us of the early twentieth-century preoccupation with the mysterious division between Earth and Heaven.

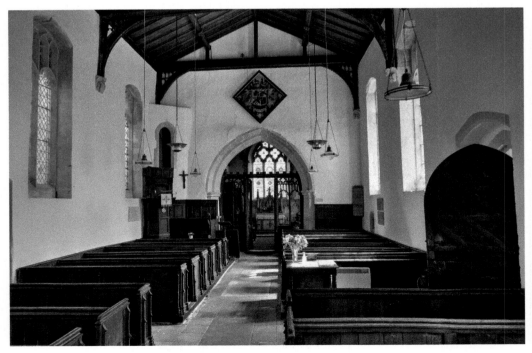

Abington Pigotts. Interior looking east. The former door to the rood loft can be seen over the pulpit.

2. BABRAHAM, ST PETER

Very much an estate church, St Peter's is reached down a private track through the parkland of Babraham Hall and then across a footbridge which spans the River Granta. Like most churches in this part of the county it is built of flints collected from the fields, giving a warm creamy exterior, and it is easy to pick out the horizontal building 'lifts' in the walls that indicate the individual seasons of building work during construction. Additionally, in the south wall two square putlog holes survive which would have supported the wooden scaffold when the church was built. In the east wall, and only visible outside, are two blocked lancet windows of thirteenth-century date which were once part of a group of five that lit the chancel. The huge fifteenth-century south porch must have witnessed many secular gatherings, whilst the north porch is rather less ostentatious. The visitor steps down into a barn-like interior represented by a late medieval nave and aisles leading to a rather short thirteenth-century chancel. There is a west organ gallery and plain medieval font with a fifteenth-century cover.

The east end of the south aisle is raised into a platform over a burial vault which supports the most important memorial in the church, to brothers Sir Thomas and Richard Bennet, Royalist supporters during the Wars of the Three Kingdoms. Whilst there is no documentary evidence to support the claim, it is likely that this was carved by the artist Jasper Latham who worked with Christopher Wren at both Hampton Court Palace and St Paul's Cathedral. He had an inventive approach to portraiture in marble, often placing his figures in

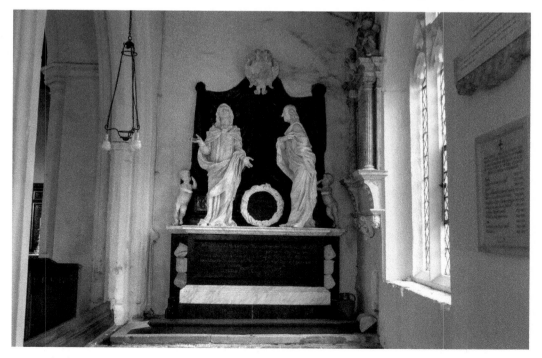

Babraham. The colossal memorial to Richard and Sir Thomas Bennet, dating from after 1667.

unusual poses. These two gentlemen hardly seem to acknowledge one another and, like all Latham's works, have blank expressions. These two brothers married two sisters, and although they were both heiresses, they do not merit being carved on the monument, or even being named on it! Hopefully they rest securely in the vault below. Sadly, their family failed in the male line in 1701, and later in the eighteenth century the estate passed to the Adeane family whose benevolent hand is much in evidence in the church.

The interior is a haven of black and white until we come to the east window, designed by John Piper and installed for Sir Robert Adeane in 1966. It tells the story of St Peter in bold colors, with panels representing his boat, the Keys to the Kingdom of Heaven and the Cock that crowed at the Betrayal. There are other small scenes above – often missed by the visitor is the keyhole! Beneath the window is a reredos installed in 1700 – dated on an inscription on the central cartouche. The Decalogue, Creed and Lord's Prayer must once have been flanked by paintings of Moses and Aaron as was the fashion at the time, but they have long gone. The delightful altar rails are also dated – 1665 – on the central rail and the chancel is lined with memorials to the Adeane family whose seven funeral hatchments adorn the ceilings around the church. As the church is not open all the time it is best to check in advance of a visit.

3. BARNACK, ST JOHN THE EVANGELIST

Barnack is known across the east of England for its quarries whose limestone built many a familiar church, so it is perhaps obvious to write that its own commanding church is built of the same material. Set in a huge churchyard in the now-bypassed village, two exterior features are of note. Firstly, the Saxon tower with later spire, and secondly the thirteenth-century porch. The two lower stages of the tower date from the early part of the eleventh century and incorporate features typical of the period – long and short work on the corners and pilaster strips on the vertical faces. In the centre of the lower stage on the south side is a contemporary sundial with a trefoil headed plant filling its upper half, whilst just below the clock is a larger piece of Saxon carving with a vine of trefoil headed leaves surmounted by a cockerel. The upper stage and spire date from the thirteenth century.

The church is entered through the important south porch, one of the earliest in England. Here stone has not just been used for the walls, but for the roof also. Its walls internally are decorated with blank arcading, and you may wonder why such a functional area is so beautified – but medieval weddings and other ceremonies took place in the porch – making it almost as important as the church through which it was entered. Inside, Barnack church is large and light. Screens separate the nave and aisles from the eastern areas. The north aisle was the first extension to the original nave and its Norman arches are wide and surrounded by typical chevron decoration. What is not typical, however, is the splendid carving on the capitals, which takes the form of waterleaf mouldings surrounding a little head. This in itself shows that the high quality of craftmanship first seen at the church when it was built was still in evidence 200 years later. From the nave the view back towards the tower shows the almost brutal quality of the original Saxon arch, with no decoration at all.

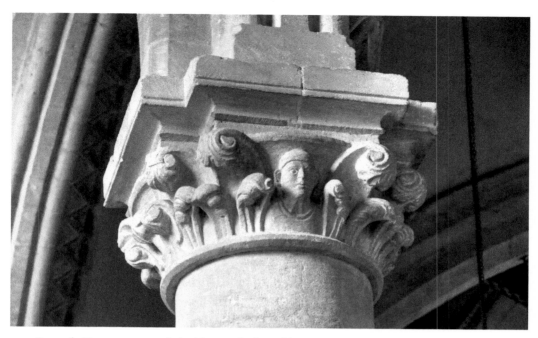

Barnack. Romanesque capital with waterleaf moulding incorporating a tiny head.

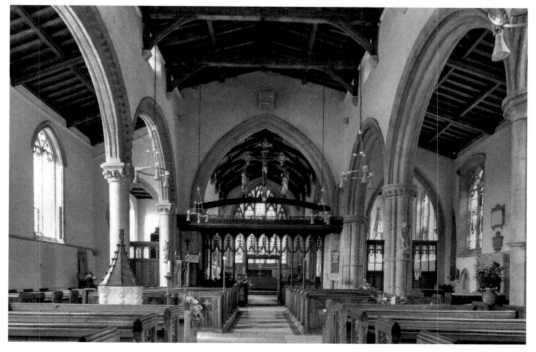

Barnack. Interior looking east. Compare the piers and capitals. Those on the right are later.

In the north aisle is a small rectangular panel depicting Christ blessing which was discovered hidden in the floor in 1931. It is Byzantine in style with a forward-looking face, detailed robes and bare stomach. It cannot be later than the early Norman period and may even be slightly earlier. The south chapel also houses a fine sculpture. This is below the image niche on the north side of the altar and depicts the Incarnation of Christ. Normally we see the Annunciation with the Angel appearing to Mary, but here Mary is visited by the Power of the Holy Spirit. Above her is the inscription in Latin 'Mary in her contemplation of Jesus'. How it survived the Reformation we don't know, although it was fairly new at the time and perhaps the donor was still alive and didn't allow its destruction. At the east end of the church the altar is flanked by four nineteenth-century panels depicting angels after Fra Angelico by the firm of Salviati which was incredibly popular in Victorian England.

4. BOURN, ST HELENA AND ST MARY

Every visitor remembers the odd, twisted spire that surmounts one of the grandest thirteenth-century towers in the county. It is known that the nearby castle was destroyed during a siege in 1266 and it is possible that the rebuilding of the church at this time shows that its predecessor was also a casualty. The abundant use of ashlar stone to create decorative arcading on the bell stage of the tower shows that this was not a rebuilding on the cheap, the buttresses and stair turret being constructed wholly in ashlar. Quite what happened to the spire, which not only twists but changes diameter halfway up, is unclear, but probably relates to a gap in building prior to its completion.

Inside, reached through a Romanesque doorway, the early thirteenth-century work continues with the nave arcades, but interestingly, the capitals on the south side take the form of a very late use of Romanesque design. The clerestory windows above are simple quatrefoils in circular frames (best seen from outside) which are a later thirteenth-century design. A hundred years later transepts were added to north and south. The north transept contains some niches that must once have housed statues, whilst in its west wall is the only surviving Norman window in the building, but, given that the transept is fourteenth century in date it has been moved from elsewhere. The south transept is smaller, and raised high above the floor of the church to create a burial vault (see also Babraham). In the chancel are sixteenth century stalls and a fine fourteenth-century sedilia, with delicate openings pierced in the divisions between the three seats. It's easy to see how much the floor level was raised during the 1875 restoration, as they are now unusable.

The great treat for lovers of high-quality church furnishings is the reredos and two windows by Sir Ninian Comper. The reredos is a standard design, with the Lamb of God and Pelican in her Piety either side of the Crucifixion, but the east window is a tour de force, depicting the Risen Christ (see the wound on his foot) Our Lady and St Helena. It dates from 1936. Ten years later Comper came back and designed a window in the north transept showing The Annunciation. His signature of a strawberry plant can easily be seen in the bottom right-hand corner. Another, much simpler work of art not to be missed is the labyrinth set in Victorian tiles beneath the tower.

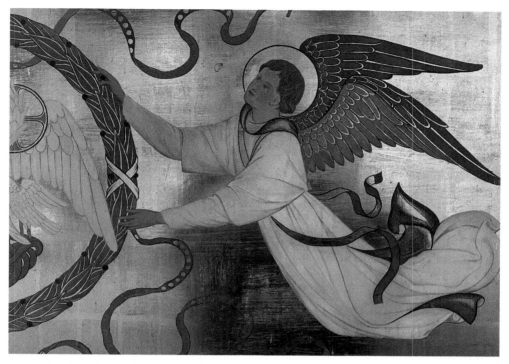

Bourn. Angel on the reredos, designed by Sir Ninian Comper, 1936.

Bourn. Strawberry plant in stained glass, the signature of Sir Ninian Comper, 1947.

5. BRAMPTON, ST MARY MAGDALENE

A large, almost urban, church that now serves an ever-growing village, Brampton has many things to interest the visitor, and pro-actively encourages tourism. The earliest work here is the chancel which has irregular blank arcading along its internal walls, which dates from the thirteenth century. It was just for decoration and doesn't indicate entrances to long-demolished chapels as one might otherwise guess. To the south of the altar is a set of three misericords which record secular scenes. Each has two small supplementary scenes in tiny roundels, which are sometimes more interesting than the main subjects. One has been interpreted as a writer, although I think he must be doing something else as he's working on his lap and not on the table. His companion roundel shows a damaged monkey. Another

Brampton. This vignette by C. E. Kempe and Co. shows Lord Allenby entering Jerusalem in 1917.

pictures harvest time with a man blowing a horn in the central scene. The third is of a man cutting cloth with an incredibly large pair of shears – the cloth being secured to the table by tacks. Where these misericords came from is uncertain; it may have been from Hinchingbrooke Priory with which this church had long associations.

Further along the south wall is a good example of a low side window which was opened at the Elevation of the Host to increase ventilation. It is now filled with stained glass of Christ with the woman at the well. The rood screen is fourteenth century in date and the central doors retain their original ironwork. Nearby an opening from the chancel to the rood loft stairway is unusual – the bottom of the stairs is now hidden in the former north chapel behind the organ, and it is unusual to have a secondary opening into the chancel.

In 1920 the east end of the south aisle was formed into a chapel by the addition of screens designed by Sir Ninian Comper on which are displayed twenty-five shields of arms relating to the Earls of Sandwich who at that time lived at Hinchingbrooke. The altar frontal here is Italian, and of the seventeenth century. Further along the aisle, above the door into the south porch, is a fragment of fourteenth-century door, sadly damaged during a fire in 1994.

Above all, Brampton is known for its stained glass of nineteenth- and twentieth-century date. The east window is by the firm of C. E. Kempe and Co. Ltd and is a memorial to the 8th Earl of Sandwich. It contains images of the Kings of Judah as well as some popular local saints such as Hugh of Lincoln and Etheldreda of Ely. The same firm produced six other windows in the church including the memorial windows in the north aisle which have roundels at the base. These exquisitely drawn vignettes include one of Lord Allenby entering Jerusalem via the Jaffa Gate in 1917, juxtaposed with Richard the Lionheart who had visited the same city 800 years earlier.

Brampton. Medieval trades are displayed on this fifteenth-century misericord.

6. BURROUGH GREEN, ST AUGUSTINE OF CANTERBURY

Standing at the end of a lane leading from the village green, this is such an easily recognisable church with its three distinctive gable windows lighting the south aisle. That these features survived the nineteenth century show that the Victorians laid a very light touch here. At the time that most churches were being restored, the rector, Charles Wedge, had been here for forty years and so the ideas that might have been brought in by a younger man were absent. After his death the church was served by a non-resident rector, so Burrough Green survived in its rustic state.

The lack of stained glass and a limewashed interior creates a calm space little altered since the eighteenth century when the roofs were ceiled, and the windows strengthened with iron bars still visible outside. This must have been the date when the chancel arch was removed as two classical urns today stand on the capitals where the arch would have started, and it is certainly the period when the current benches were installed. The font bears the date 1672 and was purchased after a report said that the church and its furnishings were in a dire state of repair. The exterior walls show evidence of destroyed chapels at the east end and there was once an altar in the south aisle where an angle piscina survives. Unusually the cill of the south window has been lowered to form a simple sedilia, or seat for the

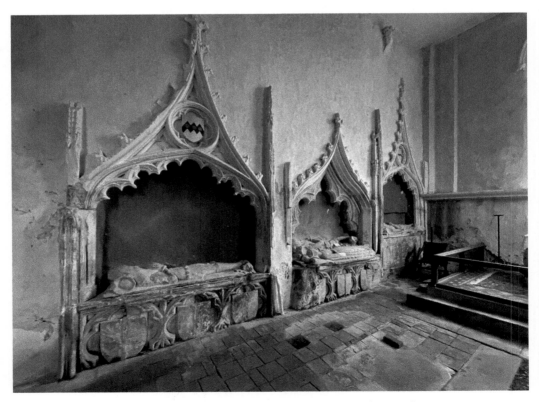

Burrough Green. Three magnificent tomb recesses dating from the fourteenth century.

clergy. In the chancel is a more traditional form of sedilia, with three seats, dating from the late thirteenth century. These are dateable by their associated double piscina which was only used in the late 1290s. Its two drains were used for the washing of the chalice and for the fingers of the priest. One drain hole is currently blocked, but a bit of jiggling reveals its existence.

The reason that this church is famed is for a set of six medieval stone effigies. Four are set into arches in the north wall of the chancel and two will be found in the north aisle. Although names are ascribed to them, it is only by local folklore. That they belong to the de Burgh family and their successors the Ingoldisthorpes is without doubt, but we cannot be sure who is who. Anyway, most of the effigies are not in their original locations within the church – some must have been in the long-demolished chapels and at least one is recorded as having been outside for some time. None of them is in good condition and of course they have all lost what original colour they had on their armorial shields, which would have helped identification. The most interesting survivor is under the centre arch where the male effigy sits on a bed of stones, looking all the bit like balls of cotton wall. Only two other monuments, both in Norfolk, display this same feature, which may allude to an uncomfortable time for his soul in purgatory.

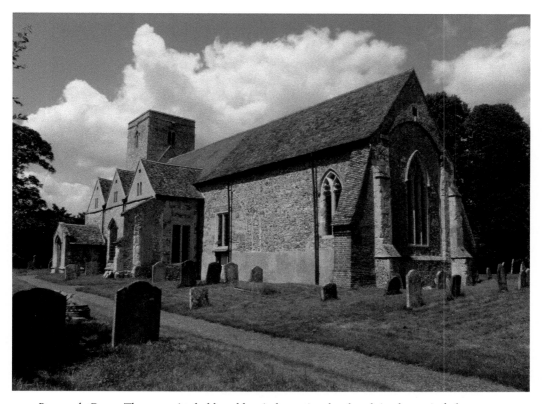

Burrough Green. These unmistakable gable windows give the church its domestic feel.

7. BURWELL, ST MARY

An enigmatic church, the history of St Mary's is much longer than a first glance might suppose. Burwell is a village built on the Fen edge and all its architectural influences come from inland. The base of the tower is predominantly Norman, and the north wall of the tower is most telling being built of coursed flint and including a complete pilaster buttress. These are usually associated with Saxon work, but the Saxo/Norman overlap lasted longer in these remoter parts of eastern England. It contains a blocked Norman window and other blocked windows, and bell openings can be seen higher up.

After such early riches the rest of the church is the result of a major fifteenth-century rebuilding, resulting in one of the most impressive late medieval interiors in Cambridgeshire. It is likely that this work was to the designs of Reginald Ely, better known for his work at King's College Chapel, Cambridge. What is more certain is the name of John Benet who paid for the work, for an inscription recording this runs across a beautifully traceried panel surmounting the chancel arch. Ignore the royal arms which were carved onto the central shield in the early nineteenth century, though they look well. It would once have contained statues and have had painted shields of arms. If these had survived the Reformation they would have been destroyed by the iconoclast William Dowsing when he visited the church in 1644. Luckily, he and his men didn't destroy the carvings that form one of the most magnificent roofs in the county.

The central bosses are very deeply carved – my favorite is the long-necked bird with something in its beak. From the bosses run arched braces, their huge expanses pierced with tracery, but it is the horizontal wall plate which joins each brace that is the treasure here, for each one is carved with a scene. Binoculars are essential to see them – and a bright day helps, too. Look for the greyhounds chasing a hare, the Host with the Lion of St Mark, chained lionesses and a pair of

Burwell. This medieval head of a bearded man is one of many roof bosses in the church.

Burwell. This inscription over the chancel arch records the munificence of John Benet.

Yale – the heraldic beasts with swiveling horns often associated with the arms of Lady Margaret Beaufort. Unusually most of the stonework in the church is local clunch, rather than imported limestone coming down the River Cam. Perhaps Cambridge provided a more financially attractive market for it.

8. CAMBRIDGE, ALL SAINTS

A little off the beaten track, this is the most architecturally important Cambridge church, in a townscape that has plenty from which to choose. All Saints is a nineteenth-century replacement of a medieval predecessor which stood on another site. At a time when you could build a decent plain church for £2,000, at £5,000 All Saints was quite expensive, although the architect, G. F. Bodley, had already pared down his original, more lavish, ideas.

Cambridge was the birthplace of what is now called The Ecclesiological Society, so it is fitting that its greatest nineteenth-century church should be based on the Society's principle that a church building should be of the best possible design and fitted out to the highest quality. You step into a dark interior, made even more so by the stenciled decorations on the wall that replicate fabric, and you soon realise that it is not one design, but several, seemingly randomly abutting each other. The roof, too, has stencilled decoration including the Sacred Name repeated. At the east end of the nave is a celure, or canopy of Honour to the rood screen beneath. The east wall of the nave depicts Christ in Majesty surrounded by the Heavenly

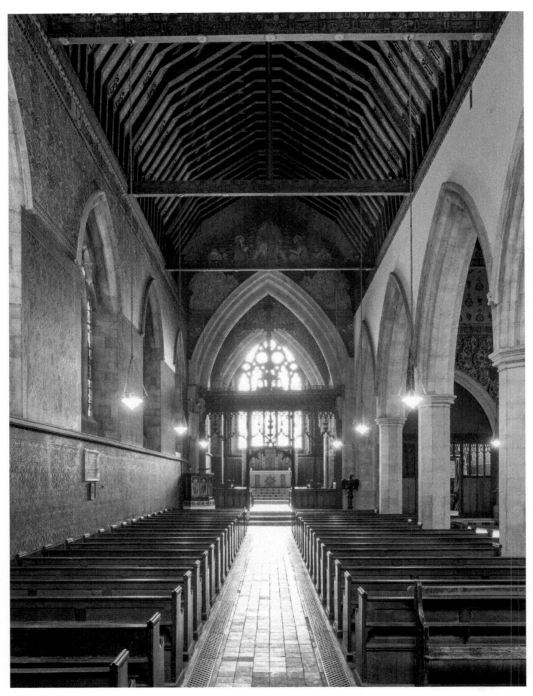

Cambridge, All Saints. Interior looking east. GF Bodley's masterpiece of 1863. (Photo by Adrian Powter)

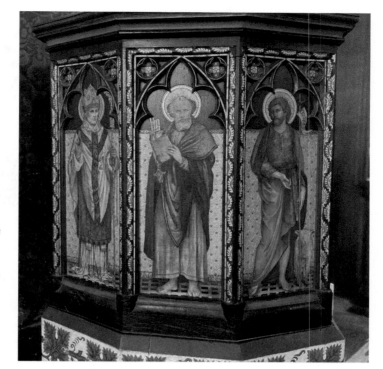

Right: Cambridge, All Saints. The pulpit was painted by Wyndham Hope Hughes.

Below: Cambridge, All Saints. It is the wall decoration that creates the atmosphere of this nineteenth-century church.

Host ranging from large pink-winged angels to tiny blue cherubs. Surprisingly, whilst there is a rood loft; the cross which stands on it is plain, flanked by two tall candles, rather than the expected crucifix. The chancel sits underneath the tower and spire, so has a flat ceiling, whilst light streams through the enormous east window. The glass here is by the famous William Morris and his colleagues Burne-Jones and Ford Madox Brown, installed in 1866. I especially like the figure of King Edward the Confessor, centre right, his orb tucked into his cloak.

The church has a south aisle and transept, the latter containing the organ and a myriad of tablets brought from the old church when it was demolished. The wooden pulpit was decorated by Wyndham Hope Hughes, a pupil of the more famous Charles Kempe, whose firm produced several windows for the church, including several delightful vignettes including the Angel appearing to Zechariah whose incense seems to have got rather out of control! Another of their designs commemorates Saintly Cambridge Anglicans. A much more recent, and rather incongruous window given its medievalising neighbours is by Douglas Strachan (1944) depicting Acts of Mercy.

The church has limited opening so please check The Churches Conservation Trust website.

9. CASTOR, ST KYNEBURGHA

This church is in my 'top twenty-five' churches in England for its combination of location, architecture and history. It stands within a large Roman settlement which was succeeded by a monastery founded by St Kyneburgha in the seventh century. This was destroyed by the Vikings but rebuilt in much the form we see today by the Normans. The spectacular tower displays some of the finest Romanesque work anywhere and this is not just visible on the outside, but inside too, where the four great piers supporting the structure have majestic carvings on the capitals. A pair of binoculars will help the visitor appreciate the scenes which include two men fighting and a boar hunt. Surviving from an earlier period is the exquisite carving of St Mark which is now set into the north aisle. It may date from the earliest years of the monastery.

At the west end of the north aisle are some animated wall paintings showing scenes from the life of St Catherine. These date from the fourteenth century and the famous 'Catherine Wheel' is clearly visible. The roofs of nave and aisles date from the fifteenth century and are ornamented by a series of painted figures. In the nave golden angels have outstretched wings, whilst in the aisles brightly coloured figures carry liturgical objects from keys to musical instruments. However, it is the work in stone that we really remember at Castor. Over the main porch is a depiction of Christ in Majesty with circles above him to represent the moon and the sun. It is of Saxon date, so has been reused in the later porch.

When the Normans rebuilt the church, they helpfully left an inscription to record the fact. It is situated over the chancel door, on the outside. It reads 'The dedication of this Church was on the 17th April AD 1124', although the year appears to have been added later – Norman dedicatory inscriptions elsewhere rarely include the year! Today this inscription sits above a modern representation of St Kyneburgha by local sculptor Mark Sharpin, added in 2015.

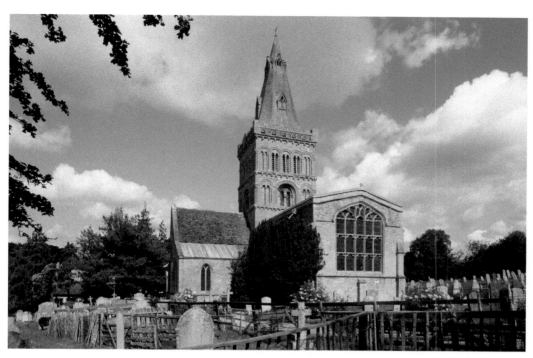

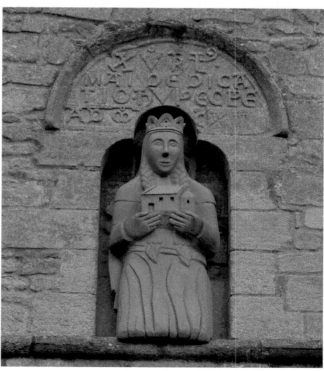

Above: Castor. Viewed from the east the Romanesque crossing tower dominates the church. (Photo by John Salmon)

Right: Castor. Here we see the dedication stone of 1124 above the recent statue of St Kyneburgha by local sculptor Mark Sharpin.

10. CATWORTH, ST LEONARD

This is one of several local churches to have a tall spire, but here it sits rather splendidly atop a tower whose proportions seem all wrong because it was built with a rectangular projecting stair turret on the south face which pushes the bell opening off centre to the west. The tower and spire are built of limestone ashlar, whilst the church walls are of rubble construction. The amazing south doorway, protected by a porch, with its capitals of stiff leaf decoration is thirteenth century, but once inside you'll find that everything else was rebuilt in the fourteenth. The clerestory means that this is a light church, and the unplastered walls show changes in the stonework – for example, the west wall where the thirteenth-century former roofline is clear to see.

The royal arms have a rare text at the base taken from the Book of Isiah: 'And Kings shall be thy nursing Fathers and their Queens thy nursing Mothers'. The wooden pulpit and rood screen are both medieval, although they have been reconstructed.

I always remember Catworth for its variety of monuments. It contains two thirteenth-century stone coffin lids (one behind the organ), of which one is carved with the typical double-omega design, showing that it was probably manufactured

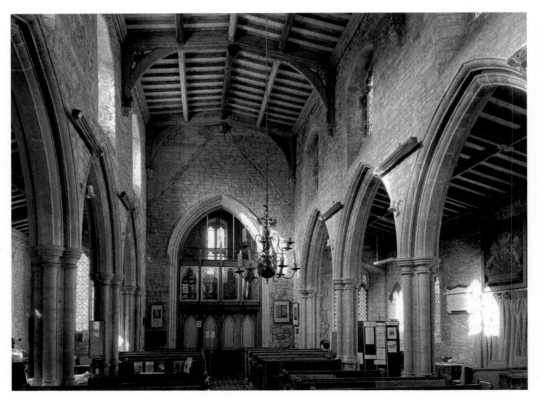

Catworth. Interior looking west showing the earlier roof line against the tower wall and the fourteenth-century arcades.

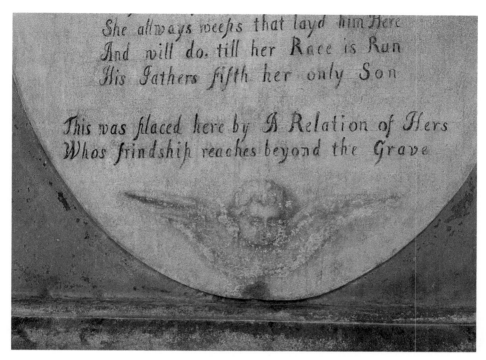

She allways weeps that layd him Here
And will do. till her Race is Run
His Fathers fifth her only Son

This was placed here by A Relation of Hers
Whos frindship reaches beyond the Grave

Catworth. Painted mural monument with a grisaille cherub and the setting-out lines still clearly visible.

in the Barnack region. By the door is a large wall memorial where the inscription is painted, not carved, and where even the cherub at the bottom and shield of arms above are painted in a manner similar to grisaille work. It commemorates John and Rose Lawton. The latter died in 1710, her only son having predeceased her. Part of the inscription relating to the death of her son was written by her brother John Dryden (1631–1700) who was our first Poet Laureate: 'Stay, stranger, stay, and drop one tear, She always weeps who laid him here, And will do until her Race is Run, His father's fifth, her only son'. At close quarters the scored lines for painting the inscription may be clearly seen and the memorial ends with an intriguing statement: 'This was placed here by a relation of hers, whose friendship reaches beyond the grave'. On the opposite side of the church is the memorial (signed by S. Manning Junior) to Sir Felix Booth (d. 1850). He was the owner of Booth's London Gin and is best known as having financed a private expedition in search of the Northwest Passage in 1829. In recognition of this, unsuccessful, attempt he was created a Baronet by King William IV. Above the memorial hangs his funeral hatchment depicting his shield of arms of 'three boars heads, serrated and upright'. The all-black background shows that Booth was a bachelor.

11. CHIPPENHAM, ST MARGARET

Chippenham is a lovely estate village, beautifully tended, and the parish church is certainly worthy of such a fine setting, with its tower facing square on to the

main street. There are lots of things to see on the outside. Firstly, the tower has three fine image niches on its west front which must have looked resplendent with statues. The nave and aisles are roofed in lead, but the chancel has a steeply pitched, tiled roof. This used to be a common feature of churches and reminds us that until 100 years ago these parts of the building were in different ownership, and just because work was carried out on one part, it didn't necessarily follow that the owner of the other part would do work at all! The chancel was all but rebuilt in the 1880s and the texture of the walls here is entirely different, with more tightly packed field flints than in the earlier part of the buildings. You can also see this in the east wall of the south aisle which was a Victorian addition – the vertical line marking the original south-east corner of the chancel was left in the wall.

Internally, the building is mainly of the thirteenth century, with the nave having an impressive series of arches to each aisle. Sadly, these were all damaged in a fire in the mid-fifteenth century so have a very ragged appearance. Above hang an impressive series of seven hatchments dating from the eighteenth and nineteenth centuries, whilst overshadowing them is a simple hammerbeam roof. On the north wall is a huge medieval wall painting of St Christopher that must

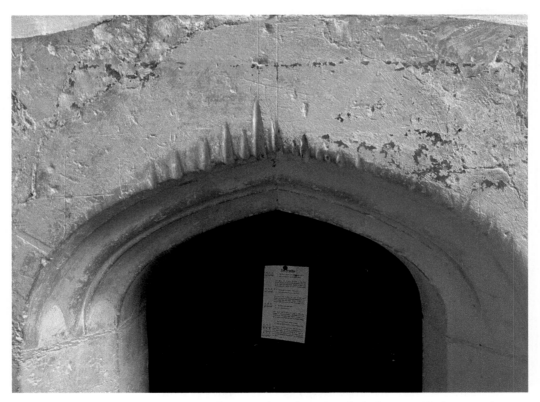

Chippenham. These grooves above the tower door show that the bell rope rubbed against the stonework each time it was pulled.

Chippenham. Rustic and charming painted decoration of the north chapel roof.

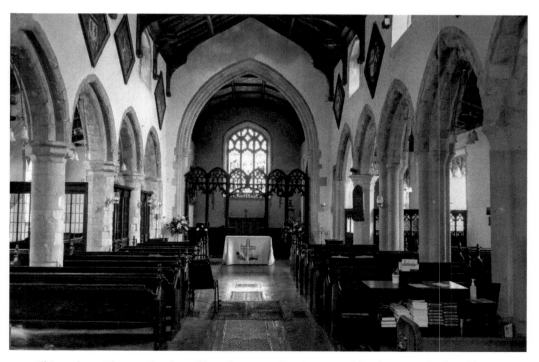

Chippenham. The arcades show fifteenth-century fire damage, whilst the screen looks odd as it has lost the filling between the tops of the arches.

have been overpainted on several occasions as it is difficult to work out just how his arms work. Notwithstanding, his pure white beard is particularly striking, and the Christ-child balancing on this shoulder always looks to me like he's playing a game of cops and robbers! Also on the north wall is a rare painted memorial of the early seventeenth century with a naïve portrait of a lady in a white dress kneeling on a plump cushion. The artist didn't attempt to inscribe real words on the book she is reading and her inscription itself has worn away. The rood screen dividing nave and chancel has an odd appearance as the vertical panels have been separated from their loft leaving rather exotic crenelations. Nearby, the roof of the north chapel is naively painted with a series of colourful designs.

Before we leave, we must look at the tiny door leading up the tower. The top of its arch is incised with deep vertical grooves made by the bell rope rubbing against it over the course of many generations. I think the ringer must have felt weary and sat on the stone steps holding the bell rope which he pulled at the appointed time without bothering to stand up!

12. CONINGTON, ALL SAINTS

All Saints is an exceptionally interesting church which stands in the parkland of the former Conington Castle. Now retired from regular use, visitors are welcome by appointment. Like many churches in the area it is constructed of limestone rubble and the better-quality Ketton stone for the ashlar work. We enter via the west door into a stone vaulted chamber, the stonework of which was originally much higher up in the tower. It is a dark and mysterious space. Suddenly you enter the tall and bright church which was more or less built in one go around 1500 and which may have still been under construction 100 years later. The solid piers of the arcades are unusually solid and multi-shafted.

Like most estate churches the character here has been created by the two main landowning families, the Cottons and their successors the Heathcotes. The former family installed fictive monuments to their predecessors the Royal House of Scotland in an example of historicism that is only matched in another English church at Chester le Street in County Durham, for example, one monument, erected in around 1604, commemorates Prince Henry of Scotland who died in 1152 and who was buried at Kelso Abbey. Another recalls his son, Prince David, who died in 1219, and who for a while had been heir to the Scottish Crown. Sir Robert Cotton commissioned these not just to recall previous owners of the estate but also to show his allegiance to James VI of Scotland following his accession to the English throne the previous year. Cotton was a notable antiquarian whose library went to form what is now the British Library.

In the south chapel is a rare, and well-preserved, medieval effigy of a Franciscan dating from around 1330. He may be the Lord of the Manor, Bernard de Brus, who died around that time. It's always worth looking behind organs for examples of organ blowers' graffiti – and there is plenty here. Of interest too is a chair with carvings of The Annunciation and a sedilia with delicately carved vaulting. In the churchyard is an American War memorial.

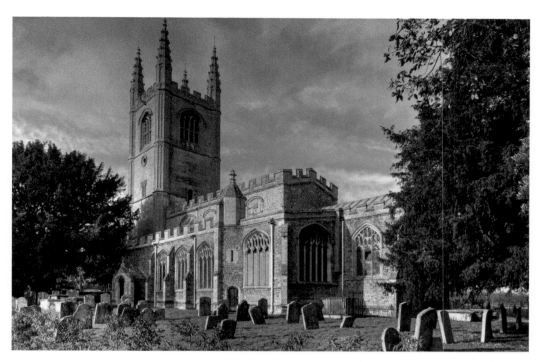

Above: Conington. This large limestone estate church dates from the late Perpendicular period.

Right: Conington. Monuments in the south chapel cover a period of over 600 years.

13. COVENEY, ST PETER AD VINCULA

The church stands on a ridge overlooking the Fens with superlative views towards Ely Cathedral. Yet there can be no dissimilar churches, for Coveney is a tiny rubble-built structure with very little architectural pretension. After the nave and chancel were built in the thirteenth century there was a short gap before the west tower was added on – you can see it wasn't originally planned as there is a west window in the church that is now blocked by the tower. The USP of the tower is that it has a processional passage running under it, allowing a circumnavigation from north to south. This must show that the west door of the church was once the main entrance and that the path to it was regarded as important enough to be kept when the tower was built. There are other similar passages in East Anglia, but they are rather uncommon.

On the south side of the church, it is possible to see an original thirteenth-century lancet window, flanked by later fourteenth-century windows that are much wider. Just to the right of the lancet window it is possible to see a feint vertical line in the stonework which marks the original east end of the church before it was extended. Once inside you'll find that you have stepped into a lost world – that of the High Church movement of the late 1890s, when the church was beautified by the introduction of splendid furnishings. This was a project led by the enthusiasm of the Patron of the Living, Athelstan Riley. He was a young man of independent means who, at the age of twenty-five, purchased the

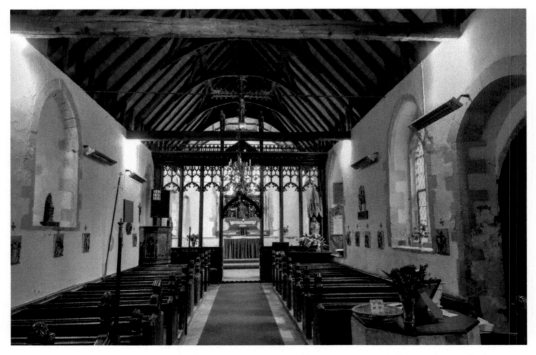

Coveney. The character of this rich interior was created by its patron, Athelstan Riley, in the late nineteenth century. (Photo by Adrian Powter)

patronage, which meant that he could appoint the clergy he wished, to match his own preferred style of worship. He went on to acquire the patronage of many other churches. His three main additions here were the pulpit, screen and reredos. The former is of early eighteenth-century Danish origin and depicts the Saints and the Virtues. Apparently, Riley found it in an antique shop. The reredos was made to hold panels of fifteenth-century carved German art, whilst the screen was entirely new. Together with an east window by Geoffrey Webb they make up a very rich, and unexpected, interior.

Whilst these furnishings are undoubtedly splendid, they rather dominate the interior where the medieval bench ends would be worth a journey in their own right. Dating from the period immediately before the Reformation, they include images of Christ's wounds, a Tudor rose and a Triskele symbol. The latter may refer to Bishop Stanley of Ely (1506–15) whose father was the last person to be called King of Mann. On your way out note the jingoistic inscription on the First World War memorial lych gate: 'Who died to save their country from the CHAINS of a foreign YOKE'.

14. CROXTON, ST JAMES

St James' is an almost unknown church set in the parkland of Croxton Hall and certainly worth the effort in making prior arrangements to visit. Estate churches often have a feel of their own and this is no exception, reflecting the families who

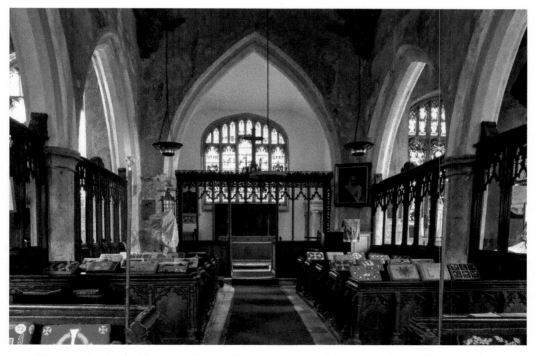

Croxton. Interior looking east showing the prominent parclose screens that enclose chapels to the north and south of the nave.

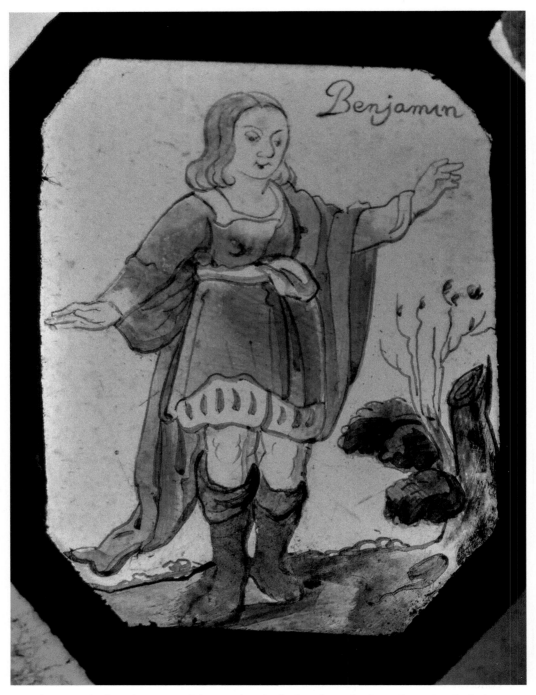

Croxton. A charming piece of imported stained glass from the Low Countries. It depicts Benjamin, younger brother of Joseph, from the Book of Genesis.

have inhabited the 'big house' over hundreds of years. You step down into a nave filled with medieval benches – those at the back having some detailed carvings on the end. At the east end of each aisle is a parclose screen. That to the north now contains the organ, whilst on the south is the private pew for Croxton Park, complete with settees. In the south window there are some delightful fragments of glass. Many are medieval including a lovely angel playing a harp and a bishop with a book, but my favourite is a piece of continental glass depicting a playful Benjamin. At each corner of the nave is a large carved angel holding a shield of arms. These represent the Leeds family who owned the estate from 1571 to 1820. To the right of the altar is the monument to Prebendary Edward Leeds (d. 1589) who was Master of Clare College, Cambridge, owner of Croxton and rector of this church. The brass on top of the tomb shows him in civilian dress together with a Latin inscription. In the churchyard is the grave of Queen Elizabeth II's great-grandfather Charles Cavendish Bentinck, from the family of the Dukes of Portland.

15. Diddington, St Lawrence

The story told of most churches is one of an extended chancel. Here the opposite happened during the post-Reformation period, as can be seen from its brick exterior. Yet it surely had been extended in the thirteenth century when the north aisle with its circular piers was constructed. There never seems to have been a south aisle, which meant that there was space to create a south chapel off the nave in the late Tudor period. This almost always means that there was a prominent local family and in this case it was the Taylards, some of whom are commemorated within. I'm certain they were responsible for the rebuilding of the tower as well, which draws us towards the church through the parkland of the demolished Diddington Hall. It is a stately brick tower of three stages, with a picturesque stair turret climbing up the south face to the first floor, its tiny quatrefoil windows adding an exotic touch. The brickwork is known as 'English Bond', where the bricks are laid in separate courses of stretchers and headers (sides and ends). Mixing the two (Flemish Bond) wasn't to appear for another 200 years.

The church is much larger inside than you expect and filled with light from the clerestory windows. In the north aisle is one of the fifteen medieval domed chests to be found in the county. It would have been made in north-eastern Europe, probably in the fifteenth century, and imported via the River Great Ouse. This particular example is completely armoured to make it fire-proof and also to make it more secure. It would have required five keyholders to open it!

Between the nave and south chapel, mounted on the wall, is a rather damaged but nevertheless remarkable brass to William Taylard and his family dated 1505. Whilst most of William is missing, as are his armorial bearings and two groups of children, his wife is intact. I love the way she has placed her rosary on the prayer desk in front of her. Down either side of the brass are images of Christ and five saints – see if you can identify them by their symbols. In the south chapel is a good collection of mainly continental glass, some of it coming into this church within the last 100 years. Of particular interest are the roundels which originated from the Low Countries, including St Anne holding the Virgin and Child, The Betrayal

Diddington. Netherlandish roundel depicting St Lawrence, who was martyred on the gridiron he is holding.

of Christ and St Lawrence with his grid iron. Some very jumbled English glass includes a delicate image of St Margaret. Finally, there is an impressive collection of funeral hatchments to discover, relating to the Thornhill family who first came to Diddington in 1730.

16. DULLINGHAM, ST MARY

St Mary's is a noble church standing on a steep hill above the village green and built of flints collected from the fields. It comprises an aisled nave, west tower, chancel and south chapel which is built to the south of the aisle rather than off the chancel which would be the more usual location. No doubt it served as a

Lady Chapel rather than as a private chapel for the local big family. It must have once been a very striking feature of the interior, partly separated from the aisle by a wooden screen, the mortices of which survive. In the south aisle too is the entrance to the rood loft staircase, and its upper blocked opening is visible in the nave. Here the capitals of the chancel arch have been hacked away on both sides to take the floor of the loft that formed the top of the rood screen. Higher up, in the moulding of the chancel arch itself are very clear mortices that held a wooden infill, or tympanum, which would have filled the whole of the arch. On this would probably been painted a Doom scene, similar to that still to be seen at Wenhaston in Suffolk. The higher mortices supported the carved rood figures of the Crucified Christ, Our Lady and St John before their removal by law in 1547.

Under the tower are two huge benefactions boards, recording gifts to the parishioners of money, cash and bread. Here too are four funeral hatchments carried at the funerals of the Jeaffreson family in the first half of the nineteenth century. One of the shields of arms is surmounted by a viscount's coronet to remind us that Harriet, Viscountess Gormanston had married Christopher Jeaffreson in 1794. She is also memorialised in the church by a tablet showing a disconsolate woman sitting on a stool with the inscription 'To maternal affection'. It is one of a series of works in the church by the Westmacott family of sculptors, who were the 'society' sculptors of the late Georgian period. Their patrons here had made their fortunes overseas, so could afford the best.

Two memorials are sculpted and signed by Richard Westmacott the Elder (1746–1808) including the tall, draped urn on the south chancel wall. Opposite is an effigy lying on a chest tomb by Sir Richard Westmacott (1775–1856), the more famous member of the family. It is an early example of the medieval-style tomb chest revival and commemorates Lt General Christopher Jeaffreson (husband

Dullingham. The stately exterior shows a former south chapel built onto the south aisle, rather than off the chancel, which was more usual.

Dullingham. The signature of Richard Westmacott the Elder on a Jeaffreson memorial.

Dullingham. The signature of Sir Richard Westmacott on a second Jeaffreson memorial.

of the Viscountess) who died in 1824. In the chancel is a late thirteenth-century double piscina and at the west end of the nave is a fifteenth-century font which was later painted with the royal cypher of James VI of Scotland to commemorate his accession to the throne of England.

17. DUXFORD, ST JOHN

Until St Peter's became the parish church in 1879 there were two separate parishes here reflecting the manorial patronage of local landowners. Now St John's stands in retirement, its Norman architecture attracting many visitors. From the outside we can see that this was built as a linear church – one comprising three cells of nave, tower and chancel. These were once relatively common, but the majority were later extended by the addition of transepts to make them cruciform in plan. Not here, where the later extensions took the form of a north chapel and north aisle, the former an exuberant and lavish display of architecture. Work of this period is often associated with the Black Death (1348) which appears to have made survivors more devout and which in turn led to the construction of new devotional spaces.

Inside we find an amazingly light church with no stained glass, uneven floors and ochre walls. The arches that support the tower to east and west are both of the Norman period and like much of the church retain original painted decoration. The westernmost arch has diaper patterns whilst the easternmost has a depiction of the Agnus Dei, or Lamb of God. Other paintings tell the story of The Passion with the sleeping soldiers in the garden of Gethsemane and a rather grisly martyrdom of a saint, probably St Agatha, whose breasts are being pierced with swords.

The North Chapel contains the finest stone carvings in the church, comprising two image niches either side of the east window. They are not quite a pair, and it is worth spending time looking at the differences in carving – for example the right-hand niche has a floriate head carved at its base. This chapel was used as a village school during the post-Reformation period and one can imagine the impression it made on the children taught there in the church of their ancestors. On the base of the pier into the north aisle are lots of deep vertical scratches in the stonework. These are the result of pious parishioners taking grains of stone from the consecrated building to use at home, often for medicinal purposes. It used to be thought that these marks were left by those sharpening swords but it's impossible

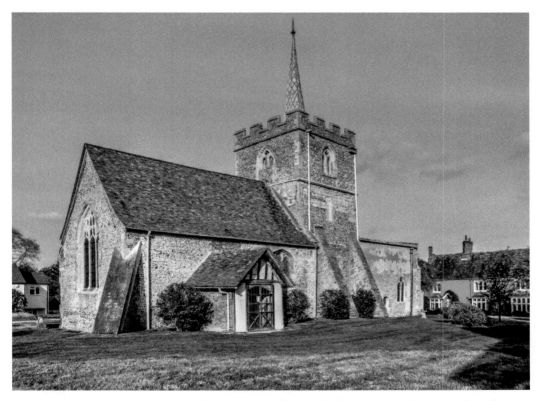

Duxford. This is a good example of a 'linear' church which has a central tower. (Photo by Adrian Powter)

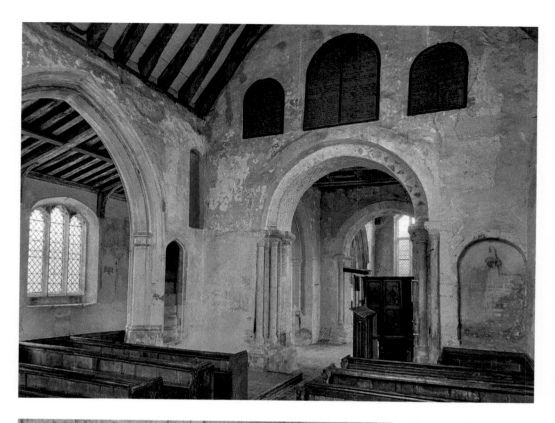

Above: Duxford. Interior showing the rood loft staircase, Romanesque chancel arch, Decalogue, Creed and Lord's Prayer. In the distance some wall paintings can be seen.

Left: Duxford. These sleeping soldiers are part of a series of wall paintings depicting Christ's Passion. (Photo by Adrian Powter)

to sharpen a blade vertically, and that suggestion is now discredited. There are lots of other marks on the stonework left by more artistically able people including images and inscriptions. Over the tower arch the Decalogue, Creed and Lord's Prayer date from the eighteenth century and the staircase to the rood loft survives in the north pier. This remarkable and atmospheric church will detain the church detective for hours.

18. ELSWORTH, HOLY TRINITY

In any other part of the country Elsworth would be a chocolate-box village besieged by visitors in summer, attracted by its picturesque brook and gorgeous cottages. But the world has left Elsworth unrecognised, including its church, which stands on high ground to the east. It is a large and impressive building whose items of interest need teasing out. In the east end of the chancel is one of the finest groupings of thirteenth-century double piscina and sedilia in the county. These always date from the late thirteenth century, so we can be sure they were originally in the previous church here, for the present building dates from the middle of the fourteenth century. The two drains are for the priest to wash his fingers (as in all piscinae) and for rinsing the chalice. The return stalls are a rare survivor of pre-Reformation times, set off by fixed book rests with panelled cupboards for the precious books to be stored away. The benches are backed by linenfold panelling. In the north aisle is the stone staircase that

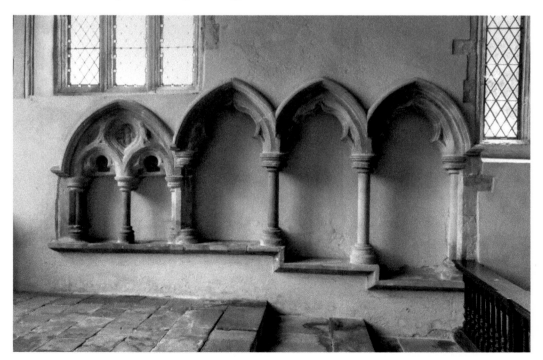

Elsworth. Here we have a sedilia with three seats for Priest, Deacon and Sub-Deacon, together with a double piscina for the priest to wash his fingers and chalice.

Elsworth. The now-blocked low side window used for ventilation during Mass which retains its original iron bars and hinges for a shutter.

originally led to the top of the rood loft, and the upper doorway can be found above the pulpit. Higher still are eleven medieval figures which came from the original roof, but in their present position it is very difficult to make out any details.

Throughout the church are indents in the floor slabs indicating where memorial brasses were once set. There are over a dozen of them, which tells us that this was a wealthy place in the later medieval period. Even though we may not know their names we can see if they were civilians or clergy by their outlines, and if their partners were commemorated with them. In the aisle a tablet records the ecumenical gift of Elizabeth Banks who left money for the poor to be distributed both by the rector and churchwardens here, but also by the minister and deacons of the Particular Baptist Chapel. Dominating the rear of the church is the eighteenth-century former reredos which was moved out of the chancel in 1892 to form one side of the vestry. As a result there is now much light in the chancel as this move allowed the insertion of the present east window.

A short walk round the outside reveals a couple of items of interest. On the south-west buttress of the tower are three triangular holes which once supported

a fence or railing whilst on the south wall of the chancel is a well-preserved low side window, complete with its iron bars. It is now thought that these windows were opened for ventilation at a specific point in the Mass.

19. ELTON, ALL SAINTS

This region of England is well-known for its country houses, and this church stands on the estate of the Proby family who live at Elton Hall. Unusually the tall west tower is set within the north and south aisles and represents the latest medieval building period, early in the sixteenth century. It is constructed of smooth, or ashlar, stone and has a prominent sundial on the south face. The bell-stage is marked at top and bottom by an unusual frieze of quatrefoil decorations. The south porch is of around the same date as the tower and has three delightful image niches above the entrance which is formed by a Tudor arch. The smooth façade of the porch has proved too tempting for generations of Elton folk who have scratched their names and initials all over it! The door originally installed in this porch is still in use, and we step down into a large light church and are confronted by the arcades which date from the fourteenth century. They are quatrefoil in shape and relatively unusual in the area where twelfth- or fifteenth-century arcades are the norm.

The south aisle was rebuilt around the same time as the porch and the roof is a little odd as the weight-bearing members are curved into the wall instead

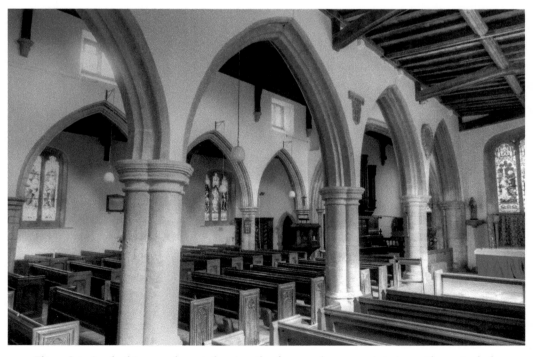

Elton. Interior looking north-east showing the fourteenth-century interior with particularly unusual roof construction in the aisle roof.

Elton. Detail from one of three windows in the church by the firm of Morris and Co.

of sitting on the wall plate above. High over the chancel arch you can see the doorway that formerly led onto the rood loft, which would have run across the exceptionally wide chancel arch. The chancel is part panelled and has a very different atmosphere to the rest of the church. In the south aisle are some rather good monuments, in the form of architectural tablets, to the Proby family by notable sculptors of the seventeenth and eighteenth centuries. Elton church is known for its three stained-glass windows by the firm of Morris and Co. which contrast with the more traditional Victorian windows elsewhere in the building.

20. EYNESBURY, ST MARY
Eynesbury is contiguous to St Neots, with the boundary between the two marked by a small bridge. Their churches are a few hundred yards apart and in terms of townscape, St Neots wins. However, its little-visited neighbour can hold its own in terms of history and furnishings and continues to dominate its own little urban centre, set on a busy road junction.

The building dates from the thirteenth century, although successive alterations have rather blurred what is original and what is replacement. The tower is in a

most unusual location – at the east end of the very narrow south aisle. It is later than the church and space didn't allow for its construction at the west end where the building is almost on the road. Narrow aisles, where they survive, show us what the majority of them must have been like when built – just a passage-like feature to north or south of the nave, constructed to allow the laity to contribute to the liturgy of the church through processions inside the building. The majority of early aisles were later replaced, usually when seating came in, with much wider structures. At Eynesbury the north aisle has been widened, although its

Right: Eynesbury. One of the medieval bench ends which probably depicts a Yale, a heraldic beast with swivelling horns.

Below: Eynesbury. Interior looking east showing the 'high church' interior of this thirteenth-century building. (Photo by Simon Knott)

Eynesbury. Fine nineteenth-century glass by the firm of Heaton, Butler and Bayne dating from the 1860s.

original arcade survives, with circular piers and a mixture of different very late Romanesque capitals. Conversely, the south aisle retains its original proportions but the circular piers here have been replaced in the octagonal form. There are some bench ends which must be of the same date as this rebuilding. The majority are of animals, both real and mythological, my favourite being the Yale. Later in date is the seventeenth-century pulpit with inset marquetry panels, which would not look out of place in a City of London church. Amazingly its leg is a twentieth-century replacement by the architect Marshall Sisson.

The restoration of the church in 1857 came at a time when it was illegal to place a cross on a Holy Table, so the reredos has a rather discrete rayed cross set into it to be seen from the nave. The rood figures are twentieth century and are to the designs of Sir Albert Richardson. The church contains a good selection

of Victorian stained glass, of which the most important is the two-light window depicting Christ, Martha and Mary which is an early design by Robert Bayne, soon after he joined the firm of Heaton and Butler.

21. FORDHAM, ST PETER

As soon as you arrive at this large church you see its USP, for what appears to be a north porch is, in fact, an almost freestanding two-storey chapel abutting the north aisle. Such chapels were usually added onto the chancel and were very rarely double height. The date of its arrival is rather uncertain, but architecturally it looks to be from the period just before the Black Death. The ground floor, now used as a community room cum porch, boasts some wonderful stone vaulting, whilst the upper room, or chapel, visible from inside the church, has large windows and has echoes of Prior Crauden's Chapel at Ely Cathedral.

There are medieval mentions of a chantry foundation at Fordham and it must surely have been installed in this building. In the lower room is a delightful piece of stained glass depicting the head of an unknown bishop. The church itself is very dark, so it is best to visit on a bright day. It received a thorough late Victorian restoration, and wall decorations in the form of blank arcading and named saints were still being added in the twentieth century. Those in the chancel were designed by the famous firm of Clayton and Bell, while others were by lesser-known artists including Cambridgeshire sisters Minnie and Edith Townsend. On the north chancel wall stands a carved representation of the Decalogue and Lord's

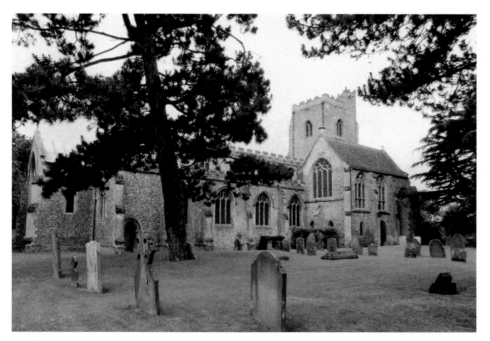

Fordham. The exterior from the north-east showing the almost detached north chapel dating from the fourteenth century which sits against the north aisle. (Photo by Bernard Davies)

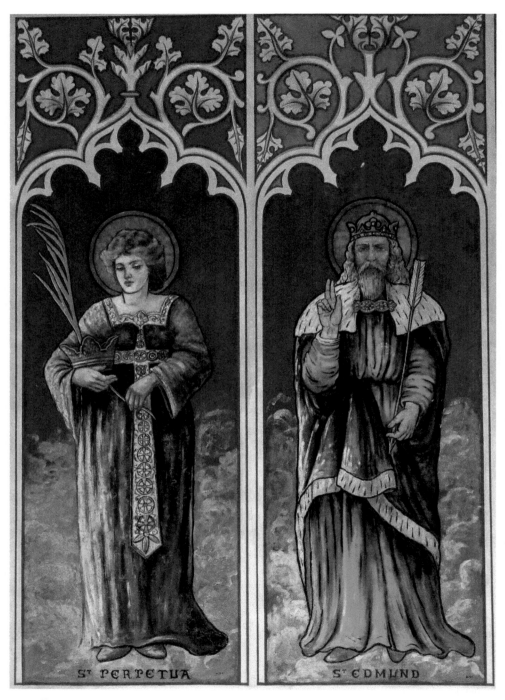

Fordham. Nineteenth-century murals in the chancel depicting St Perpetua and St Edmund by Minnie and Edith Townsend. (Photo by Simon Knott)

Prayer which were given to the church in 1871 and originally stood, as tradition dictated, on the east wall. Sadly, they didn't stay there for long as fifteen years later the ensemble was replaced by a more elaborate gabled reredos depicting the Crucifixion, as part of the extravagant alterations taking place throughout the building. Also Victorian are the two extensions to the chancel. One for the organ, the other, on the south side, as a tiny private chapel for the Lord of the Manor who, we are told, had a disagreement with the priest of the day who was becoming more popular amongst the villagers than him. It contains two dirty hatchments which would look lovely cleaned.

22. FOXTON, ST LAURENCE

Each county has its own distinct church characteristics, and for Hertfordshire it is a little spikey spirelet atop its towers. They have spilled into Cambridgeshire as well, as Foxton boasts one that is only slightly thicker than its adjacent flagpole. Also to be found in this corner of the county are

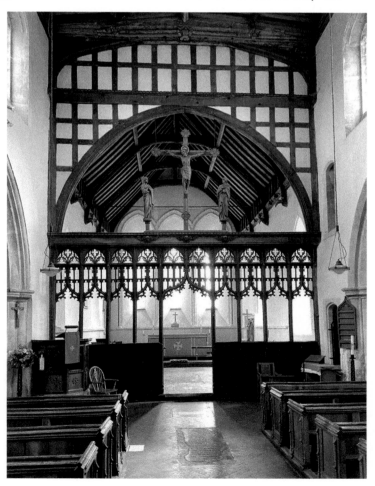

Foxton. The timber and plaster infill makes it hard to picture what this stately church would have looked like pre-Reformation, although much of the screen is original.

Foxton. Exterior from the south. The tower is topped with a 'Hertfordshire Spike'.

the massive timber ceilings that were designed to support low-pitched, lead-covered roofs. This is the glory of Foxton, with many high-quality carvings on the lofty structure. Most important amongst them is a couple who must represent those who financed the building work. They face outwards, kneeling in an act of prayer beneath a scroll which might have once been painted with their names.

Individual donors survive too, as do the symbols of others, including an almost perfect White Hart. It is important that they have survived, as this was one of the churches where all the obviously religious images were destroyed in 1644 by William Dowsing on his trail of destruction across the eastern counties. The benches beneath are fifteenth century as well, though of a relatively plain design. Dividing the nave and chancel is an original rood screen, although the tracery and rood figures with their silly cherubs are later. The chancel arch itself is wooden and supports a utilitarian wood and plaster wall which would have originally been plastered and then painted. The mortice holes in the tie beam of the roof above show that it cannot be the original arrangement. There are some good fragments of gold and green medieval glass in the window tracery and in the chancel the three widely spaced lancet windows of thirteenth-century date stand on the typical round roll-moulding of the same date which runs around the chancel walls.

23. GREAT GRANSDEN, ST BARTHOLOMEW

Set in a picturesque village on the edge of steeply sloping ground, St Bartholomew's Church is grand indeed, being mainly fourteenth and fifteenth centuries in date. I love the way in which the north porch, aisle, nave and tower are all battlemented, creating a bravura set piece reminding the medieval viewer of stability in unstable times. The tower is the earliest work, dating from the mid-fourteenth century, possibly after Lady Elizabeth de Clare, granddaughter of King Edward I, granted the church to the embryonic Clare College, Cambridge (see also the entry for Duxford). The rest of the church is around a hundred years later and retains many of its original benches and the skeleton of its rood screen.

After the Reformation a door was cut in the south side of the rood screen to facilitate access to a private pew! The nave side of the screen still has traces of its original paintwork in the familiar alternating red and green backgrounds. More outstanding woodwork survives in the roof. The eight-bay nave roof has delightful carved musical angels, reminiscent of the roof at Duxford and possibly by the same carpenters, given their shared patronage. The aisle roofs are less elaborate,

Great Gransden. Royal arms. Anglican churches should always display a set and this is a particularly colourful example.

but equally as fine, that on the north side boasting a celure of honour. This was an ornamentation to give honour to an altar that once stood at the east end of the aisle. The roof here has been given a ceiling, the junction of its ribs being marked by fretwork foliage. How amazing it would have looked when originally painted! Two stained-glass windows attract the eye. The most striking is a memorial to 405 Squadron which was based locally. It was installed in 1989 to the design of Glen Carter. Another is to be found in a jumble of medieval glass. Hiding in the patchwork effect is a perfectly preserved tiny figure with a halo, looking upwards, his face full of character. I'd like to think he was St John at the foot of the Cross, but perhaps we'll never know.

24. GUYHIRN CHAPEL

One of the least prepossessing churches in Cambridgeshire, Guyhirn has a fascinating history, being one of the few to have been built during the Commonwealth (1649–60). This was a period when the way in which churches were used was very different to anything that had gone before and is remembered especially as a time when decoration and ritual of any sort in church was frowned upon. Many existing church interiors were altered, and damage done. Infant baptism was abandoned, and church fonts often ejected.

Here on the Fens a community of 'strangers' had recently developed. These were refugees from the Continent – mainly northern France – who had at first settled in

Guyhirn Chapel. This delicate eighteenth-century plaster ceiling was a later addition to the severely plain protestant chapel.

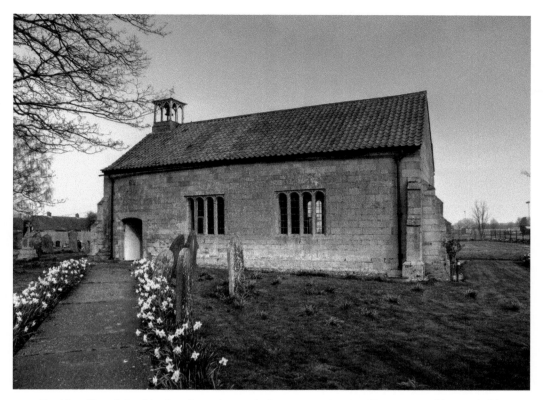

Guyhirn Chapel. In this view from the south the construction is of limestone ashlar, probably reused from a monastic house.

north Lincolnshire where they were not warmly received by the locals, who had forced them out. They moved south to worship in the privately owned church at Thorney, the former abbey, where they could use their native language with the blessing of the landowner and their employer, the Earl of Bedford. However, this was only a temporary measure, and it may be that many of them disliked the huge, previously Catholic, church in which they found themselves and decided to build their own, more suitable church, at Guyhirn. As such it is as simple as a church building can be. The south wall is constructed of blocks of Barnack limestone, which was probably first used at Thorney and then brought here by the strangers, whilst the north wall is rather more picturesque with its brick and stone mixture. There is a little bellcote whose bell is dated 1637, so this, too, must have been brought from elsewhere, as the church is a few years younger. Inside, the church is full of its original upright benches – too close together to allow for kneeling, which was frowned upon at the time. Although today the church has a Holy Table it probably would not have done originally and sadly the original pulpit doesn't survive in its original form, so we don't know exactly where it would have been. Running around the walls is a row of hat pegs which were often removed by the Victorians during restoration, but here they stayed as the

Victorians built a replacement church down the road. For such a simple building the two plaster roof ventilators, added by the Georgians are a delightful, though incongruous feature.

25. HAUXTON, ST EDMUND

Recent conservation work allows us to study the construction of this church in a way that is almost impossible elsewhere. The outside walls have been repointed in lime mortar, which has emphasised the many different building materials and phases of construction. The nave is Norman in date. Its south doorway, complete with Mass dials and adjacent tiny window, survive. Each has a similar, though not identical, pattern of carving above it, in the form of an intricate interlaced design. The walls around each are built of flint pebbles and the horizontal building lifts – each representing one season of work – can clearly be seen here. One season must have been particularly short as they only achieved around 30 cm in height. The wall to the left of the door has been rebuilt with clunch and further west a whole area of flint wall was removed when the present window was installed in the fourteenth century. At the east end of the nave is a prominent blocked arch, now filled in, which was the entrance to a south transept. In contrast to this spectacular display of 'vertical archaeology' the chancel is rendered, although a later and wider Norman window is visible.

Inside this well-cared for church the Norman character is preserved by the massive chancel arch which dates from the early 1100s. Following the Fourth Lateran Council of 1215, most chancels were extended or rebuilt and here the work included the addition of altars either side of the chancel arch. The elaborate and deeply moulded arch that formed part of its architectural setting survives

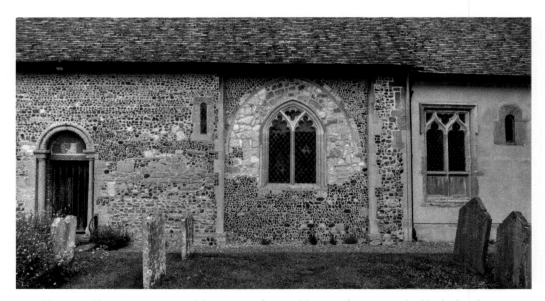

Hauxton. Here we can see two Norman windows, a Norman doorway and a blocked arch to a former chapel. The building 'lifts' of the original nave are very clear on the left.

Hauxton. Medieval
wall painting of
St Thomas Becket.

on the north side, where we can also see that the south transept was matched
by one on the opposite side. Here is a rare fifteenth-century wooden wineglass
pulpit. Its rectangular panels must once have been painted with images of saints.
On the south side of the church, hidden behind a red curtain, is another treat, for
here is an early painted image of St Thomas Becket. He stands holding his staff
in his left hand and in an attitude of blessing with his right. Becket's eyes stare
straight out, but above the viewer, and just in case we didn't recognise him, his
name 'TOMAS' is written above his shoulders. It must have been limewashed over
at the Reformation, so was invisible when William Dowsing visited here in 1643
to destroy what he called 'popish pictures'. It was uncovered during the Victorian
restoration of the church in 1860.

26. HELPSTON, ST BOTOLPH

The church will be forever associated with the nineteenth-century poet John
Clare who was born here and who is buried in the churchyard. Each summer
local schoolchildren gather at his grave. The church is entered through a door

dated 1708 and is much larger than appears at first sight, mainly dating from the fourteenth century. Although the distinctive tower with octagonal top stage and stone spire is a Victorian rebuild, it copies what was there originally.

Inside, the piers that separate nave from south aisle are of late thirteenth-century design, with a circular cross-section, whilst those to the north aisle are slightly later and are octagonal in form. The church seems uncommonly tall due to the upper windows, or clerestory, added in the fifteenth century. At the east end of the nave is a pair of smaller arches filling the join between arcade and chancel. This almost always occurs where a church reuses foundations from an earlier building and struggles to tie the proportions of the old and new. The chancel arch itself shows the distinctive scars where originally it held the ends of the rood screen and its loft, long since gone. When the chancel was rebuilt

Above: Helpston. Rare thirteenth-century pavement with geometrical designs.

Left: Helpston. The lower notch in the photo shows where the rood screen was set into the chancel arch, whilst the larger hole is where the rood loft was inset.

Helpston. The east window depicts Christ in Majesty and was designed by Francis Skeat in 1983.

in the late thirteenth century it had stone benches along the walls, the ends of which, with crude carvings, survive by the altar rails. Here too, on the south side, is a piece of original flooring, which must have been spectacular in its larger form.

The dramatic east window which depicts Christ in Majesty, was installed in 1983 to the designs of Francis Skeat. From here, looking back down the church

we can see a window cut thought the walls to either side of the chancel arch. These are hagioscopes, or squints, which allowed a priest serving at an altar in the aisle to view his colleague at the main altar. Two monuments of note include that to Mr Snowball, organist (d. 1991), and to William Farrow (d. 1814), whose inscription reads 'Afflictions sore long times I bore, and sorely was oppressed, Till God did please to give me ease, And take me to my rest'.

27. ICKLETON, ST MARY MAGDALENE

The church stands in a bend of the village street, dominating its environs by its medieval broach timber spire, covered with lead. This is punctuated on its south side by a free-hanging 'Sanctus Bell' which would have been tolled during Mass for the benefit of those unable to attend church. It now rings the hours whilst the tower also contains a ring of eight bells. The nave is of twelfth-century date with four piers formed of monolithic pillars. Local tradition says that these are reused from a Roman villa. They support very thick walls that are still pierced with their original Norman windows, although these now lead into the aisle whose roofs have been heightened. Even when in use they must have brought little light into the church, so it is obvious why the church walls were heightened and given a set of clerestory windows in the fourteenth century.

On the north side of the nave significant wall paintings survive. They were only discovered after a fire in 1979 and are remarkably early, dating from the twelfth century. It was common at the time to paint the walls in two horizontal schemes,

Ickleton. Stained glass by M. E. Aldrich Rope depicting the Annunciation. (Photo by Simon Knott)

Ickleton. Bench end showing St Michael weighing a praying soul on the right, whilst a heavy devil in the left pan attempts to have the soul for himself.

Above: Ickleton. Exterior from the south showing the Sanctus bell hanging on the exterior of the spire. (Photo by Simon Knott)

Left: Ickleton. A view of the north arcade showing the two horizontal series of wall paintings. The Last Supper is easily identified on the left-hand side.

divided by a line which ran round the nave. Here the upper scheme depicts the Passion of Christ with the Last Supper being the most easy to spot. The lower scheme appears to be a series of martyrdoms of which the central one depicts St Andrew, the X-shaped cross on which he was crucified being prominent. Unusually for England the paintings were created as frescoes, painted on wet plaster.

In the nave the majority of benches are medieval, although most have lost their decorative ends. One that survives depicts St Michael weighing the souls. Some

of the benches have their construction numbering scored into their bases, which made sure each bench was set into the correct mortise. Rather relegated to the south aisle is a delightful wooden pulpit of the same date, which really should be better displayed – it is quite a treasure. The west window of the nave was introduced as a memorial by Powell's in 1906 and the dedicatory inscription that accompanies it is on the wall below in their unique opus sectile technique. The chancel is entered through a fifteenth-century rood screen and contains a fantastic piece of twentieth-century art in the form of an east window designed by M. E. Aldrich Rope. She was one of the artists who, together with her cousin, trained at the Glass House, Fulham, which became a nursery for pioneering female artists. Here we find the Crucifixion with St Mary Magdalene holding her pot of ointment and St Etheldreda holding Ely Cathedral, which she founded. At the base are three panels which include the charming deathbed scene of St Etheldreda.

28. ISLEHAM, ST ANDREW

A visit to remote Isleham is always a pleasure. Near the church is the remains of a Norman priory church, little altered and in the care of English Heritage. Yet it is St Andrew's Church which dominates the village centre with its tall nineteenth-century tower and sequestered churchyard. A connoisseur's church if ever there was one, you need to allow plenty of time to take in all its beauties.

The main door is on the south side and is entered via a porch with shuttered windows, some of which have fourteenth-century paintings surviving in their

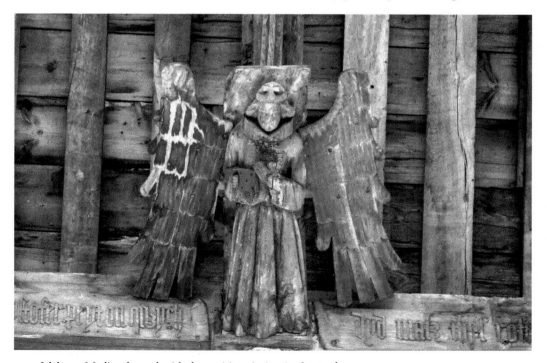

Isleham. Medieval angel with donors' inscription in the roof.

Isleham.
Seventeenth-century
altar rails, using
classical forms
popular at the time.

Isleham. The two brightly painted Peyton tombs in the south chapel are just two of many important monuments in the church.

Isleham. The elaborately decorated north arcade displays the shields of arms of the families who paid for the work.

splays – it is extremely rare to find surviving paintings in a porch. Inside we must firstly give thanks to the Peyton family who created the present church in the fifteenth and sixteenth centuries. They enlarged and beautified an older cruciform building, principally by raising the walls to create a clerestory and adding a new roof. This is an inventive composite design with queen struts alternating with hammerbeams which are terminated by well-preserved angels. Along the horizontal wall plate is a carved inscription telling us that it was the gift of Christopher Peyton in 1495. When he died in 1507 Christopher left an illuminated service book to the church but, predictably, it no longer exists. The intricate stone carvings which fill the gaps between the earlier nave arcades were also a Peyton gift, creating a very rich interior, with their shields of arms picked out in colour. In the south chapel are two large colourful Peyton monuments of Robert (d. 1590) and Sir John (d. 1616). What they lack in artistic ability they more than make up in bravura. The Peytons were themselves successors to the Bernard family whose earlier memorials survive aplenty. Unfortunately, most do not include an inscription, so it is guesswork as to exactly who they represent. One poor Bernard was totally boxed in by the Peytons! The best Bernard monument is a brass to Sir John who died in 1451, and his wife. It shows him wearing the

traditional SS collar that was a display of service to the Crown, and which became particularly associated with the Wars of the Roses.

There are many brasses to explore, and indents showing where others have been lost. On the west wall of the chapel is an indent which must have been a glorious Crucifixion scene with Sir Robert Peyton (d. 1518) and his sons and his wife Elizabeth with their daughters. In the chancel are a set of early fifteenth-century misericords depicting a variety of heads, whilst the altar rails are a spectacular design from the early seventeenth century.

29. KIMBOLTON, ST ANDREW

The church sits at the opposite end of the High Street to Kimbolton Castle, until 1950 the home of the Montagu family, Dukes of Manchester. Whilst they are well represented in the church, it is a building of much greater interest. The arcades between nave and aisles are an interesting contrast for the south aisle is made up of circular piers, typical of the thirteenth century, whilst the north arcade has alternating circular and octagonal work of 100 years later. The entrance to the rood loft is visible on the south side of the hefty chancel arch, whilst an image niche to the left shows that a medieval altar probably stood here. Each aisle has been extended to form a private chapel – that to the north at a higher level than the rest of church as it is built over the burial vault of the Dukes of Manchester.

Outside this chapel, a truly ducal porch meant that they entered their final resting place in the style they enjoyed in life. Strangely, it is the south chapel that contains memorials to the family, although their arrival in Kimbolton came at least a century after the chapel and aisle were built, and it is for this period that the church deserves to be known. The roof of the aisle and chapel are a veritable gallery of carvings, although it is only easy to see those in the chapel itself where there is more light. Here are the symbols of the Four Evangelists together with two large single figures – St George and the dragon and an angel holding a host, the latter frame a celure or ceiling above the monument to the first Earl of Manchester, though it must be earlier. Further down the aisle the bosses include a man walking with crutches, a mermaid and a man ringing handbells. These must all date from the end of the fifteenth century. Dividing the aisle from the chapel is a fine screen with original painting along the four panels at the base. They are unlike any paintings on other local screens and must have been done by an amateur as they are not of the correct scale for their location, and are nowhere near as sophisticated as the angels in the roof.

Almost hidden behind the chancel arch is the memorial to Consuelo, Duchess of Manchester (d. 1909), which was created as a low relief. She raises her arms towards Heaven where her twin daughters, who predeceased her, lean towards her through the clouds. And it is the memorial to those two daughters which draws most visitors to this church, for after the death of her second daughter at the age of twenty-one, Consuelo employed the firm of Tiffany, based in her home city of New York, to install a stained-glass window to their memory. It stands in the corner of the south chapel and depicts Christ blessing the daughters, with other family members looking on. It is

Kimbolton. This elaborate porch on the north chapel forms the entrance to the burial vault of the Dukes of Manchester.

Kimbolton. Some of the fifteenth-century angels in the roof retain their medieval colour. (Photo by Adrian Powter)

Kimbolton. A detail of the famous window designed for the Duchess of Manchester by the New York firm of Tiffany and Co.

the only Tiffany window in an English parish church and is typical of their use of opalescent glass. The tiny heads in the tracery at the top are especially beautiful.

30. LANDBEACH, ALL SAINTS

Although most of the exterior is rendered, where it can be seen it reveals a mixture of field flints and chalk. This is especially noticeable on the tower where the prominent putlog holes, where the scaffolding fitted into the building whilst it was being built, may be clearly seen. Most of the church dates from the fourteenth century, as do some of the furnishings. At that time the patronage passed to Corpus Christie College, Cambridge. The nave roof is of a hybrid construction – part hammerbeam and part reusing timbers from the previous

roof. Under each hammerbeam is an angel which retains much original colour, holding a shield depicting the arms of their donor. Angels survive in the north aisle, too, although these have been stripped of their colour. Here is a magnificent fourteenth-century tomb recess which has a tiny head of a man with one of those double-beards poking out. Perhaps it marks the tomb of one of the donors.

The rood screen must have come from the previous church as it is rather rustic and doesn't quite fit the chancel arch. In front of it stands the one item of furnishing everyone remembers: a lectern in the form of a theatrical angel. The suggestion is that it was once part of a Dutch pulpit, and we know it was purchased in an antique shop in the nineteenth century. Fragments of medieval glass in the window heads suggest that this church once had magnificent glass, but the many fragments in the east window have been brought in from elsewhere, possibly by Robert Masters, an eighteenth-century rector. You can spend hours searching through the jumble for details of interest, including a set of bells, an armillary sphere and a portrait supposedly of Lady Margaret Beaufort, mother of Henry VII, but my favourite image shows a man with an arrow in his eye. He must be Ahab, the seventh King of Israel. Some of the stalls have misericords including two that are heraldic and which allow us to date them to bishops of Ely in the mid-fourteenth century, both of which retain their original colour.

Landbeach. The notable feature of this little-visited church is its fifteenth-century roof, with heraldic angels.

Right: Landbeach. Amongst the jumble of medieval fragments in the east window is this image of an armillary sphere.

Below: Landbeach. Poor Ahab was hit in the eye by an arrow, as is shown in this fragment of medieval glass.

31. Madingley, St Mary Magdalene

The church stands inside the grounds of Madingley Hall, whose successive owners left their mark on this atmospheric building. Despite much rebuilding in the nineteenth century – which removed some of the patina of age and added the unappealing walls facing the park – it contains much of interest, starting with a Norman font of above average design with a combination of blank arcading and chevron patterns.

When the north aisle was built the church was given a clerestory on that side, and even though there was never a south aisle it, too, was suitably embellished, creating a rather odd appearance. On the chancel north wall is the all-dominating monument to Dame Jane Cotton (d. 1692). She was the last of the Hynde family who had built Madingley Hall, visible from the church, and was married to Sir John Cotton, Royalist Sheriff of Cambridgeshire who had been created a Baronet in 1641. Their family lived here for 200 years and are remembered in some fine memorials, especially unusual being the kneeling statue at the west end of the church to Mrs Jane Cotton (d. 1707), being shown as if in song. In the chancel is a huge memorial to Admiral Sir Charles Cotton, 5th Baronet, who famously commanded naval ships in the French Revolutionary Wars and the Napoleonic Wars that followed. The memorial, by John Flaxman who had studied sculpture in Italy following work as a designer for Wedgwood, is in the form of an enormous flag draped over a sword and an anchor. Charles wasn't buried here, but in the family vault at Landwade church. Nearby is the memorial to his son, another Charles, who died on board HMS *Zebra* at the

Madingley. Whilst the church never seems to have had a south aisle it has a clerestory to match the one over the north aisle, creating a rather odd effect.

Madingley. Dame Jane Cotton, who died in 1692.

age of twenty-five. His memorial is a pillar with a laurel wreath and urn. At the base his sword lies on a beach with a little collection of shells in front, and part of a boat behind. Strangely the cowry shell seems to attract the touch of visitors and has been rubbed clean. The sculptor of this memorial was Sir Richard Westmacott in 1828. Charles, like his more famous father, was buried elsewhere, this time in Malta.

Two final things should be noted. In the chancel south window is a jumble of medieval glass which contains many fascinating details. The little quarries that show an eagle with the name Ely and others with palm leaves possibly represent John Palmer who was Archdeacon of Ely in the sixteenth century. Lastly, the huge royal arms is dated 1802 and is of artificial Coade stone. If you look carefully, you can see it is signed Coade and Sealy on the plinth just below the unicorn.

32. MARCH, ST WENDREDA

Standing proudly on the outskirts of this Fenland town, the church of St Wendreda is justly famed for its sixteenth-century double hammerbeam roof which boasts the largest number of surviving medieval angels in any parish church. Like most of East Anglia's important roofs it is illuminated by a series of clerestory windows, yet this form of construction often brings in too much light to allow the details of the roof to be seen. Thankfully, coin-operated lights help pick out the angels

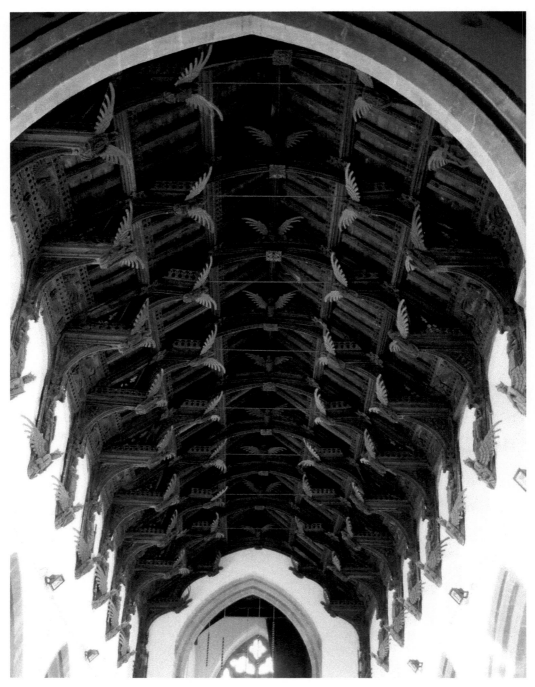

March. The well-known double hammerbeam roof dating from the early sixteenth century. It has more medieval angels than any other church.

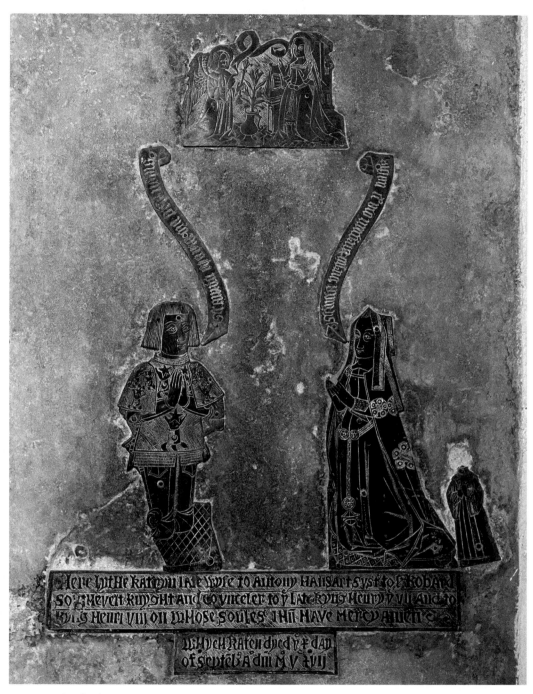

March. This brass commemorates the Hansarts who helped finance the roof. It is a miracle that the Annunciation scene above survived the Reformation.

with their musical instruments, and saints on the wall posts beneath carrying their familiar symbols.

The extravagance of the roof shows the wealth of the area – especially when it is remembered that it was probably made in Suffolk and transported all the way by water. However, the church is important in its other features, too. The Barnack limestone tower supporting a stone spire has a processional passage at its base (see also Coveney), whilst the later clerestory under the famous roof is built of flint to create a rich visual effect outside. At the junction of the nave and chancel a Sanctus bell turret points skyward containing the single bell which would have been rung during Mass at the Consecration of the Host. Whilst the exterior might suggest an homogenous interior, the visitor might be surprised by the many alterations that can be seen inside, for example, when the tower was built onto the existing church it cut into the nave, so there is a prominent half-arch on the north side by the door. The chancel, too, is a nineteenth-century creation to replace the medieval chancel that had been mucked about with in the eighteenth century. Missed by many visitors is the amazing brass to one of the benefactors of the roof, Anthony Hansart, who died in 1507. It is now set in the wall by the font and is so crisp compared to many that have been walked on for 400 years. At the top is an Annunciation scene that somehow survived the iconoclasm that followed the Reformation. The inscription is in English, which is typical of this period, although the year is still shown in Latin. A later memorial records the death in 1829 of John Johnson, gamekeeper, who was killed whilst out shooting snipe on the Fens during a thunderstorm. Whilst taking shelter in a hovel his gun discharged, leading to his death. It is a reminder to us all that parish churches are mirrors of local history, and not just of religion. Whilst at March don't miss the seventeenth-century carving depicting the Last Judgement set into the outside wall of the adjacent church hall.

33. Parson Drove, St John the Baptist

The stark tower of this church may be seen for miles across the Fen, but one needs to be at the church to see its unique feature – two small recumbent effigies in stone built onto the exterior plinth of the tower. Nobody seems to know how old they are, but they may be an example of early modern medievalising, or work of an earlier period altogether. The church is smaller than it once was as the chancel was demolished following a flood in 1613.

Inside all is light and simplicity, with uneven brick and pamment floors and nineteenth-century benches. Only the base of the tower is of any architectural pretention. Where it joins the nave is a superbly panelled arch which incorporates a tiny door which leads to the top. You can see how the floor level of the church has been raised so that one now has to step down to go up! Above your head in the stone vault of the tower are carved faces and a Tudor rose. The north-east chapel must once have been grand – its piscina survives – but in more recent times it was converted to a vestry, hence the most unexpected nineteenth-century grate! Above are three fifteenth-century stained-glass panels depicting the Blessed Sacrament, the Holy Trinity and the arms of the Diocese of Ely. In the south aisle is a large

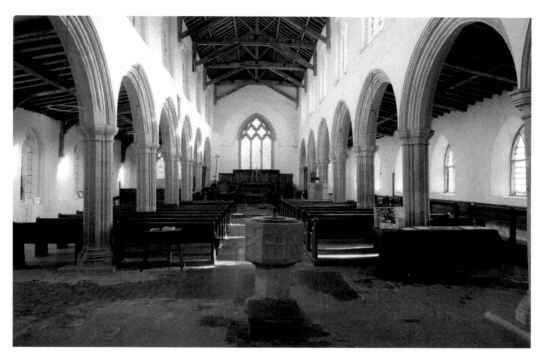

Parson Drove. Although the chancel has been demolished, the interior is typical of the late medieval churches to be found on the Fen Edge.

Parson Drove. Looking up to the stone vault of the tower, which would have helped to support the huge weight. The wooden trapdoor allowed the bells to be hoisted into the tower.

seventeenth-century Holy Table and above it the east window leans wildly as a result of settlement in the soft soil.

There are few memorials as the area was not wealthy post-Reformation, but one in the south aisle catches the eye as it is to a twentieth-century incumbent who also served in the Canadian Prairies! Beneath it in the floor is a ledgestone to the Ulyat family which is made up of four separate pieces of marble which were obviously offcuts from other jobs. Marble would have been expensive for poor farming families in the Fens who would not have been able to afford a perfect slab. High in the nave is the memorial to John Peck, a famous farmer and grazier who spent his lifetime improving things in this area for other peoples' benefit. His diary, now in Wisbech Museum, records the works he did – not just to the farmland but to the church as well.

34. PEAKIRK, ST PEGA

Standing in a quiet sequestered spot on the very edge of the Bedford Level, St Pega is a little-known but much-loved gem. Outside, at the west end of the church, it is possible to see the vertical join which marks the point where the Norman nave was enlarged by the addition of a south aisle in the thirteenth century. Nearby is a rare cast-iron coffin-shaped grave marker dated 1846. The church is entered via a Norman doorway with a tympanum of three fans, but as it stands in the thirteenth-century aisle it must have been moved to its current position when that was added.

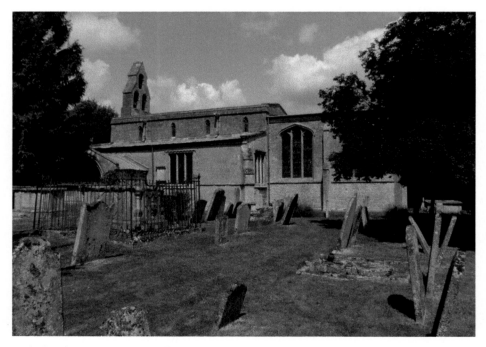

Peakirk. The exterior viewed from the south shows the diminutive clerestory added in the thirteenth century when the south aisle was built onto the nave.

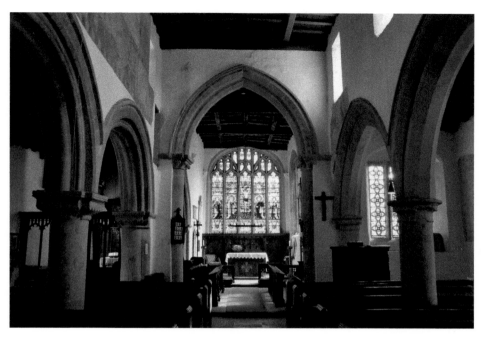

Peakirk. Interior looking east. The north aisle is Romanesque, the south Early English. The early wall paintings can be seen, and the east window is by C. E. Kempe and Co.

Peakirk. At the west end this vertical join clearly shows how the south aisle, on the right, was built against the original south-west corner of the Norman church.

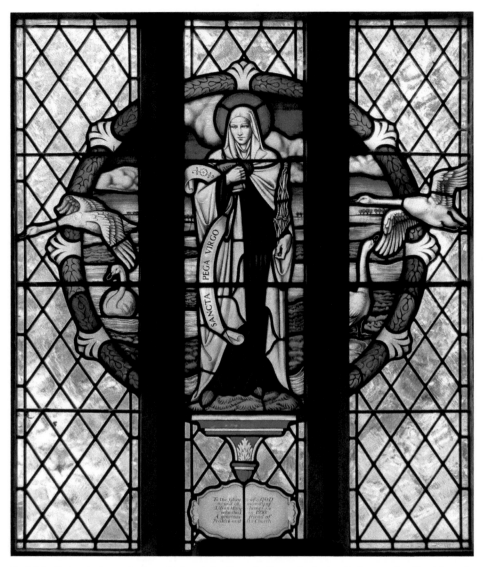

Peakirk. Stained-glass window designed by Francis Skeat depicting St Pega, who lived here in the eighth century.

Immediately one sees the wall paintings on both north walls, for which this church is famous. Rather difficult to see on a dark day there is a series of scenes from the *Passion Story* as well as individual scenes of the *Warning against Idle Gossip* and the *Three Living and Three Dead*. In the north chapel is a striking twentieth-century-stained-glass window by Francis Skeat depicting St Pega, sister of the more famous St Guthlac of Crowland (commemorated by a nearby window). After burying her brother in AD 714 she travelled to Rome where she

died five years later, although the traditional site of her hermitage at Peakirk is still commemorated. The piers separating the nave from its aisles are around 100 years apart – the capitals of the north aisle are square and typically Romanesque in style, whilst those to the south are round and of the Early English period. The chancel east window is a tour de force of 1914 by C. E. Kempe and Co., whilst nearby is a fine First World War memorial in tiles which gives far more information on the nine casualties than most village memorials. An earlier monument, to Richard Cumberland, Prebendary of Lincoln Cathedral (d. 1737), is prominently signed at the base by Edward Sharman of Northampton. Look out for the broken willow branches at the base, surmounted by a flaming heart. At the top of the monument is a pair of skulls and the family shield of arms.

35. RAMSEY, ST THOMAS A BECKET

Ramsey Abbey was founded in the tenth century and this church was originally built as the guesthouse to it, standing a few feet outside the monastic complex. Within a few decades it had been converted into a parish church, the monks having decided that their life would be easier if Ramsey's townsfolk didn't have to enter the monastery to worship. We find a similar pattern of monastic history all over England but what makes Ramsey unusual is that there was an existing

Ramsey. These numbered bench ends show that in the nineteenth century they were rented out to bring an income to the church, before the days of Sunday collections.

building that could be converted to a parish church, rather than having to start building one from scratch. This history explains why the chancel at Ramsey is so small – it was the original chapel at the end of the guesthouse.

The nave arcades are a mixed bag of designs, all of around the same period, with both Norman and Early English designs, whilst the clerestory is, of course, a later addition. The entrances to the former rood loft can still be seen between the arcades

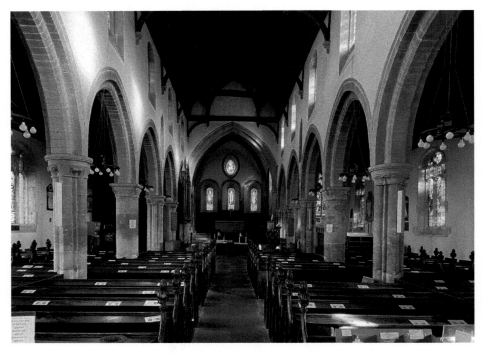

Ramsey. Interior looking east. This was originally the guesthouse for the monastery next door. The upper doorways of the rood loft show where the division between nave and chancel originally ran.

Ramsey. Stained glass by Powell's depicting the relics of St Felix being brought by boat to Ramsey Abbey.

two bays east of the chancel which tells us that the eastern end of the present nave was used as a large chancel throughout the medieval period. The font, standing on six polished pillars, dates from the time the guesthouse was converted into a church. The church was restored at the relatively early date of 1843 by the architect Edward Blore, who also worked at Peterborough Cathedral, and his are the present benches, each one numbered. Seats in churches were rented to provide an income for the maintenance of the building and occupancy of specific seats was securely guarded.

The church has several twentieth-century windows by the firm of Morris and Co., to the designs of Burne-Jones, with their familiar striated skies. In the south aisle is a window depicting Duke Ailwyn, given by local freemasons. Although it is signed in the bottom right-hand corner as being by William Morris and Sons, this has nothing to do with the designer of the aforementioned windows, as William Morris and Co. of Westminster was an entirely unconnected firm! Duke Ailwyn was the founder of Ramsey Abbey in AD 969. Other early Christian pioneers are shown in a window in the north aisle designed by Powell's. Here we find St Etheldreda laying the foundation stone of her monastery at Ely and the relics of St Felix being brought by boat to Ramsey.

36. SOMERSHAM, ST JOHN THE BAPTIST

Set back a little from the village centre, it pays to look at the exterior of the church first, especially on the south side where the various building campaigns can be picked out because each generation had a slightly different way of

Somersham. This medieval roof boss shows a wildman (or wodewose) fighting a dragon.

building. The base of the chancel is the oldest part, dating from the thirteenth century, its rubble construction using much larger stones than the later work higher up. We can also see the three different forms of window openings – the single lancets in the chancel, the slightly later clerestory windows on the nave and then the late medieval windows in the aisles. It is such a textbook example of a building that was altered over the course of 200 years. And, speaking of writing, the church contains a memorial to a famous twentieth-century composer of crosswords, John Graham or *Araucaria* as he was better known.

Inside, the arcades have been little changed, except for the addition of tiny crenellations to their capitals – look at the capitals near the chancel arch which haven't been altered to see how they would all have looked originally. Running down the central gangway is a series of black ledger slabs to prominent local families, each covering a brick-lined vault. Some of the same people are remembered by grander memorials on the walls of the chancel. To the south of the altar is a fine sedilia (set of three seats) with a double piscina, dating from around 1300 – the seats are too low to sit on today as the floor levels were altered by the Victorians. The east window is an unusual First World War memorial with the names of the dead listed on stained-glass panels, and the use of some real portraits in the figurative designs. It is by the firm of Ward and Hughes who were especially keen on this type of representation.

At the back of the church is a Victorian font mimicking the thirteenth-century period, whilst nearby is a fantastic dug-out chest – more solid wood than useable chest! However, the finest feature of the church is the roof of the nave which dates from the fourteenth century when the tall walls were given their present clerestory windows. Its many bosses retain traces of original colour and represent a variety of subjects, my favourites being a mermaid, a wodewose and a bishop. One wonders if he was meant to be a Bishop of Ely who owned property here and who were probably responsible for the village having such an enormous church of which to be proud.

37. Steeple Gidding, St Andrew
Standing at the end of a lane with views over the valley below, this unpretentious church is typical of those whose history did not involve medieval wealth or generous benefactors. Almost everything about it is 'ordinary', yet this is what makes it so characterful. Very little shouts 'look at me' in an area where many churches are blowsy. The tiny spire is set on a diminutive tower and just manages to make its presence known over the top of the surrounding trees, heralding a church where the earliest feature is the main south doorway. The chevron moulding is late Romanesque but it was beautified in the thirteenth century by having its inner opening replaced by a pointed arch, and its side supports given new pillars and capitals. I especially like that on the west side which is almost modern in the way in which its features overlap each other.

Inside, set against the west wall is a huge medieval coffin lid, well over 2 metres long, of around the same date as the doorway with the familiar double omega

design on it which suggests it may have been made in the area round Barnack. Perhaps it covered the grave of the person who paid for the alterations to the doorway? The nave has lost most of its benches, so we are able to appreciate the simple flagstone floor with one indent of the brass to a medieval couple. A large inscribed monument on the north wall records the last member of the Cotton family (see Conington) to own land in this area. The inscription shows that they were still claiming their Scottish ancestry. In the chancel is a memorial to another Cotton, Mrs Mary Kinyon (d. 1714). It takes the form of a portrait bust standing on a shield of arms (with a prominent Cotton eagle) which in turns stands on a white marble panel set between volutes. Below that is a black marble plinth which sits incongruously on a stone pedestal. A curiosity indeed, especially when at first glance it appears to carry no inscription. However, a well-placed torch shows that the white tablet is covered in text. It has been suggested that it may be a rare work of Claude David, a Frenchman who worked in England for fifteen years at the start of the eighteenth century. The colourfully tiled floor of the chancel dates from a restoration of 1874 and it must have been raised as the seats of the sedilia, formed by cutting down the cill of the south window, are no longer useable.

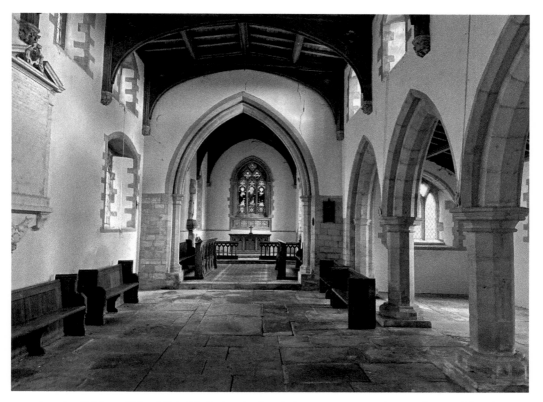

Steeple Gidding. This delightful, isolated, church has an unrestored nave floor, whilst the Victorians renewed the floor of the chancel with encaustic tiles.

38. STOW LONGA, ST BOTOLPH

This corner of the county is rich in interesting churches, and this is one of the best. People come here primarily to see the mermaid tympanum of the chancel exterior doorway, dating from the twelfth century. She is rather an angular creature with fins instead of the more usual tail, and she seems to have lost her comb and mirror. No doubt this is because she is doing a dance to impress her two friends, at least one of which is a cat! It's one of my favourite Romanesque carvings anywhere,

Stow Longa. This inscription, high up on the tower, asks for prayers for its builders, Robert and Alice Becke.

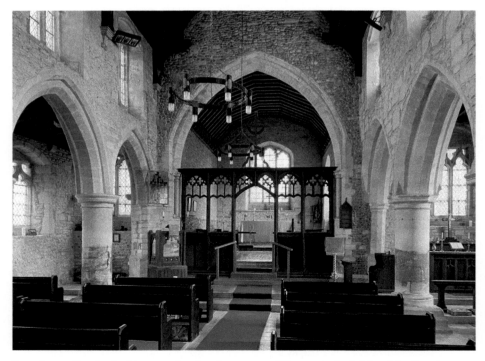

Stow Longa. Interior looking east showing the extreme difference in the height of the floor between the nave and altar. The circular piers date from the thirteenth century. (Photo by John Vigar)

Stow Longa. The Romanesque mermaid tympanum over the chancel door. She is certainly entertaining two quadrupeds, possibly a dog and a cat.

and full of fun. This sculpture excepted, the church has a severe exterior with little decoration, although the tower retains all its putlog holes – the square openings where the medieval wooden scaffolding poles would have been built into the walls.

Of great interest is an inscription in the centre of the south wall of the tower asking us to pray for Robert and Alice Becke who must have been the principal donors towards its construction. The fine thirteenth-century doorway leads us down into the church, the principal feature of which is the extreme difference in height between the nave and altar. Even the chancel floor slopes downhill! No doubt it was difficult building against a hillside and this obviously still causes problems judging by the green mould that thrives on the damp stone within.

The rood screen is fourteenth century in date and has a return bench on the southern side. Whilst this is of the simplest design it allows us to compare the patina of genuine medieval woodwork with that of post-Reformation interventions. In the centre of the chancel is an indent where once an elaborate metal floriated brass cross would have marked the grave of a thirteenth-century dignitary. Even in its incomplete form you can tell it was once a work of art of more than local importance. Behind the altar is a thirteenth-century piscina that now has a flat base, without a drain. It was later converted into a cupboard, or aumbry, as it has lost its credence shelf for the jug of water and gained a door, the locations of whose hinges and lock can be seen. In the south aisle is a fragment of coffin lid with just enough decoration surviving to show that it was of the double omega type from the Barnack area.

39. SUTTON IN THE ISLE, ST ANDREW

St Andrew's is a showstopper church, the result of late fourteenth-century largesse from the Bishops of Ely. It tells us a lot about the theatre of the medieval church when buildings were used as status symbols, for a comparison between the south and north sides shows that only the south side is really grand as it was the side that was seen from the road. The north side is remarkably plain in contrast, with less ashlar (dressed) stone and lacking the battlements which are so prominent on the south.

In the east wall is as diverse a collection of building stones as you can find. The base course is of limestone from the Barnack area, but above it is a hotch potch of flint, chalk, sandstone and ferricrete. The main porch has a stone vaulted roof, at the intersections of which are some carved bosses. This supports the floor of the parvise – a room above the porch often used to store valuables. You can see the tall wooden door to its staircase just inside the church. The arcades to north and south aisles create a barn-like interior with the arches almost touching the clerestory windows above. In the chancel the east window with its elaborate tracery is enormous – a true prayer in stone from a generation who probably remembered the Black Death and its aftermath. Its glass is by Jones and Willis of 1896. In the south wall of the chancel is a remarkable twentieth-century window by Lawrence Lee depicting the ascent of Man and the descent of God. In an accompanying explanation the artist notes that it should not be seen as an abstract work, but rather a symphony, comprised of lots of small pieces, each of which pays a significant part in the understanding of the whole. The south aisle contains an unusual image niche

Sutton in the Isle. A detail of the twentieth-century window by Lawrence Lee which he described as a symphony.

Sutton in the Isle. This vault to the tower was built of timber at a time when they were short of money and could not afford stone.

containing a medieval statue of Our Lady. There are substantial remains of the original colour scheme, especially on the underside of its carved vault.

On the other side of the church is a First World War Battlefield Cross, one of just six to survive in Cambridgeshire churches. It originally marked the grave of Captain John Edward Marshall who was killed in 1915. When he was reburied in a permanent military cemetery his family requested the return of this cross. The decayed upright shows the dampness of the ground where it originally stood.

Finally, we come to the most famous aspect of this church, its tower. It would have been the last part of the church to be built, and obviously money was not quite so plentiful. On the outside the dressed stone only rises a few feet before it is taken over by rubble construction but then they must have come into another source of income – probably from a legacy – and the top of the tower is capped by a double octagon, the upper storey of which is completely dressed stone. We have only to look a few miles across the Fens to Ely for the inspiration. Inside the church, the tower has an elaborately vaulted octagonal wooden ceiling with eight figurative and foliate bosses around the opening for hoisting the bells.

40. TADLOW, ST GILES

Not the easiest church to find, St Giles nestles in trees just above the Cambridge to Biggleswade road and is the last church in Cambridgeshire. This is quite high ground, away from the River Rhee which eventually becomes the famous Cam, and the church was deliberately built away from the risk of flooding. At first glance it is a simple building of nave, chancel and west tower, but there is much of

interest here. Firstly, the tower – which is the latest part of the building, added in the fourteenth century, is built at a very odd alignment. It is true that the church is far off the usual east-west alignment, but why the builders of the tower decided to go to such an effort to align the tower at a slightly more correct orientation will forever by a mystery. To see just how acute the difference is, stand with your back against the west door and look down inside the church.

The oldest feature of the church is the much-worn and almost forgotten incised slab to Margaret Brogriffe who died in 1493, which is right by the south door. The design would once have been infilled with bitumen and must have been quite spectacular. However, it is not for medieval features that we come to Tadlow, but rather for the nineteenth-century work introduced by one of the most famous Victorian architects, William Butterfield. He produced inventive and distinctive interiors, creating medievally inspired settings using modern materials. He worked at several Cambridgeshire churches, including at neighbouring East Hatley and here at Tadlow the chancel is a showcase of his designs. The rich tiling of the sanctuary with its three steps up to the Holy Table is designed to be read with the tiled reredos which incorporates a prominent cross. When this was created in 1860 it was still illegal to place a cross on the table, so it was built into the reredos instead. The use of different coloured marbles and encaustic tiles is typical of Butterfield's work. As he was creating a suitable setting for Communion, Butterfield ensured that nothing was out of place and often employed Alexander Gibbs to install stained glass that complemented his own work. At this period Gibbs was creating stylistically bold designs with jewel-like glass and we see it to great effect here. Add to this the painted ceiling and you have one of the richest chancels in a country church. Butterfield's work also involved designing a new roof for the nave, a plain open wood pulpit and characteristically angled font of coloured marbles.

Following major structural movement of the building, which led to its closure, the church is now in the care of a national charity, the Friends of Friendless Churches.

Tadlow. The reredos created by William Butterfield to emphasise the importance of the Mass. (Adrian Powter)

Tadlow. A detail of the stained glass designed by Alexander Gibbs whose work is often found in churches restored by William Butterfield.

41. THORNEY, ST MARY AND ST BOTOLPH

Here was one of the great monasteries of the Saxon age, founded in the tenth century on an island which already had a long ecclesiastical history, having been a well-known hermitage prior to the Danish invasion *c*. AD 870. It grew into one of the most important monastic houses, its abbot being one of those allowed to sit in the English Parliament, thus making Thorney a 'Mitred Abbey'. Its history is particularly well documented, and records show that the monks were quite acquisitive when it came to relics, thus making the abbey an important place of pilgrimage.

The church that survives today is just a tiny piece of the monastic church completed in the early twelfth century, although its architectural history is far from standard. At the dissolution of the abbey in 1539 the monks were pensioned off and the buildings and lands given to the first Earl of Bedford. He demolished most of the monastic buildings, selling the building materials on. Records tell that the chapels at both Trinity College and Corpus Christi College in Cambridge were built using stone from here.

By the early seventeenth century only the unroofed nave was left standing and it was then decided to consolidate the nave and bring it back into use as a private chapel. This is when the aisles were demolished to create what we see

Thorney Abbey. This depiction of the Harrowing of Hell has a little Devil trapped under a door in the bottom left-hand corner.

Thorney Abbey. The west door was rebuilt in 1638 in 'Gothic survival' form.

today, although it wasn't until the early nineteenth century that the east end was built to form an architecturally separate chancel and transepts. One of the most interesting architectural features is the west front which is a seventeenth-century remodelling of the late Norman original. It is clearly dated 1638 and shows what we now know as 'Gothic survival' architecture where the Gothic style is used several generations after it had become unfashionable. It is easy to see what is original and what is not by the different colour of the stone used.

Internally the church is rather box-like because it has lost its aisles, but nonetheless it is an impressive and very well-cared-for space with light pouring in through the clerestory windows. The central gangway is lined with ledger stones and there are several minor wall tablets – look for the foreign surnames – this area was popular with immigrants, some bringing their skills as engineers for the draining of the Fens, but the majority as protestant refugees from France who the Earls of Bedford allowed to hold services here in their native language. As the church was his private property this was relatively easy to achieve. Some of their descendants still live nearby.

Today the great east window contains exceptionally fine nineteenth-century glass by George Austen who had repaired the medieval glass in Canterbury, whilst there are some small panels of late medieval German glass in the nave, possibly

brought here by the settlers, or more likely by their Patron, Lord Bedford. My favourite panel shows the Harrowing of Hell where Christ descends to rescue sinners including Adam and Eve. The door of Hell has been pulled off its hinges and squashes its devil of a doorkeeper. His facial expression and his flailing legs really does say it all.

42. UFFORD, ST ANDREW

This is a majestic church sitting halfway up a north-facing slope, on the spring line. A well survives by the churchyard gate. The outline of the church from the north shows very clearly the separate roof structures of nave and chancel. The flatter roof of the nave, rebuilt in the sixteenth century, contrasts well with the tall roof of the chancel in its fourteenth-century form and reminds us that until recent times these two parts of the church were in separate ownership – when remodelling one part of the church didn't necessarily lead to the remodelling of the other. You step down into a wide, light building where the architecture takes second stage to the most interesting range of furnishings. The font is fifteenth century and has some lovely tiny lions carved underneath the bowl which are easy to miss. In the north aisle the Ten Commandments, Creed and Lord's Prayer is signed and dated 'John Everard 1790', and they also carry the name of the churchwarden who commissioned them, Edmund Negus. They would originally have been on the east wall as

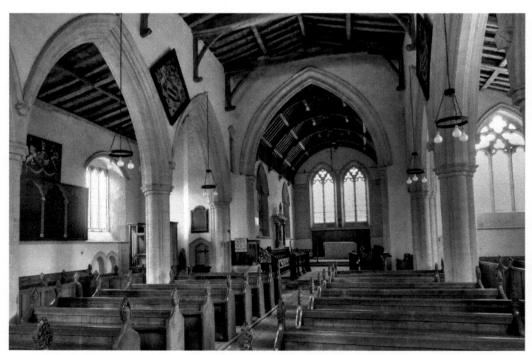

Ufford. Interior looking east. This view also shows the royal arms, commandment boards and hatchments.

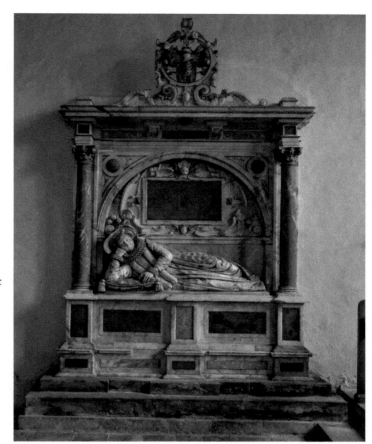

Right: Ufford. Monument of Bridget, Lady Carre, member of the Royal Household, who died in 1621.

Below: Ufford. Exterior from the north where the very different roof lines of chancel and nave can best be seen. (Photo by John Salmon)

part of an altarpiece. Above them is a royal arms of George III whose lion has an especially bouffant mane!

At the back of the church are some individualistic bench ends with amusing faces carved on the ends. High on the walls is a pair of hatchments dating from the late eighteenth century. The chancel contains a magnificent monument to Lady Bridget Carre, a member of the royal household during the reigns of Elizabeth I and James I. She is buried here in the church of her sister Katherine, her husband having predeceased her. The stained glass in the chancel is nearly all by one artist, Mary Lowndes, a pioneer of the Arts and Crafts movement. She founded the Glass House Studio in London which is recognised as the centre of the movement for glass production, and especially for its female artists. She was a great supporter of the Votes for Women movement and designed many of their banners. My favourite of her windows at Ufford is the Feeding of the Five Thousand, which includes two very tasty-looking fish! Now retired from regular use, St Andrew's is cared for by The Churches Conservation Trust.

43. WHITTLESEY, ST MARY

Few Fenland towns are so dominated by their church than Whittlesey, the spire of which may be seen for miles around. And what a spire! It is linked to the corners of the tower by small flying buttresses and it is thickly covered with carved crockets. The church itself is a mixture of periods from the thirteenth century onwards, the nave displaying both circular and octagonal piers, as well as one large chunk of wall. The rood loft staircase survives with openings to both nave and south aisles and facing the south chapel are some dainty little windows to facilitate its use. The east end of the chapel is raised above a vaulted charnel house and is lit by some lovely early glass of six saints by Heaton, Butler and Bayne. My favourite window however, is at the west end of the north aisle, and depicts three local saints – St Etheldreda, St Guthlac and St Edmund – in Arts and Crafts style. The designer was the artist Clement Skilbeck, who had been a friend of William Morris.

On a south aisle windowsill are three fragments of what must have been a high-quality fourteenth-century coffin lid with an effigy. As we walk down the nave it is possible to see carved dates in the roofs of both nave and chancel, which relate to repairs carried out in the eighteenth century. St Mary's contains several monuments of interest. In the south chapel is the bust of Sir Harry Smith, an English general who served in both north and south America, India and South Africa, as well as at Waterloo. His Spanish wife, Juana, gave her name to the town of Ladysmith. In the chancel is the odd monument to Thomas Hake, MP for Peterborough, who died in 1590. The two blank arches would once have contained effigies of Hake and his wife kneeling in prayer, but even though they have gone the architectural frame of three Corinthian columns is impressive. His funeral was held at Peterborough and was followed by a sumptuous procession to Whittlesey. Nearby is a large memorial depicting a bust of Elizabeth Kentish (d. 1792) of Kentish Town against which a winged figure languishes. Unusually the inscription, which tells us that she died from

Whittlesey. Exterior from the east where the crocketed spire dominates.

Whittlesey. The date 1744 on the roof indicates one of many dated repairs in the post-Reformation period.

consumption, also records that the memorial was designed by her husband whilst grieving in Rome, although obviously it was sculpted by a professional craftsman.

44. WIMPOLE, ST ANDREW

Safely cocooned within the National Trust's Wimpole Estate, St Andrew's remains a parish church and as such is accessible to visitors. It is one of the treasure houses of Cambridgeshire, the product of 600 years of benevolent landowners and patrons, many of whom gave thought and money to create what we see today. The earliest survival is the north chapel, which was built in the fourteenth century and which contains the bulk of the monuments for which the church is famous. It now joins onto a classical church designed by Henry Flitcroft whilst he worked on remodelling the hall in the 1740s. The view from the hall is a perfect exercise in classicism with a crisp ashlar façade, whilst the south side, facing the park, was remodelled in the nineteenth century with exposed brick and medievally inspired windows. You'd hardly think each element is from the same building. You step under a west gallery into a clean, simple, single-cell building with no structural division between nave and chancel. This was originally a space for the estate tenants as the family would have worshipped in their magnificent private chapel in the hall. The east end is dominated by a Venetian window which, in turn, is surrounded by a large wooden gilded frame. Entry into the north chapel, which is a

veritable mausoleum for past owners of the estate, is via a large twentieth-century arch and a set of steps down into what was formerly a privately owned space.

Two inscriptions on the wall record architectural improvements here. Firstly, repair of the north chapel in 1732 and secondly the rebuilding of the church in 1749. Though so close in date, they were financed by different estate owners, the property having passed by sale from the Earl of Oxford to the Earl of Hardwicke in 1740. Of the plethora of grand monuments, the oldest is to Sir Thomas Chicheley who died in 1616. It stands on the north wall and depicts his children along the base including a baby in a cot. Unsurprisingly the Oxfords weren't here long enough to be memorialised, so the rest of the memorials are to the Hardwicke family. The most magnificent is to the 1st Earl, builder of the church, who died in 1764. He was Lord Chancellor and at the base of the monument a pair of cherubs hold his ceremonial purse and mace. The sculptor was Peter Scheemakers working to a design by James 'Athenian' Stuart. On the north wall, and also by Scheemakers is my favourite memorial, to his son Charles Yorke who died in 1770, and who is represented on a portrait medallion supported by a pile of books and two putti. He briefly became Lord Chancellor, which is why the purse and mace are hanging below, but he killed himself after just three days as a result of political shame. In the centre of the chapel is the white marble brilliance of his son, the 3rd Earl of

Wimpole. The north chapel contains one of the finest groups of memorials in the county.

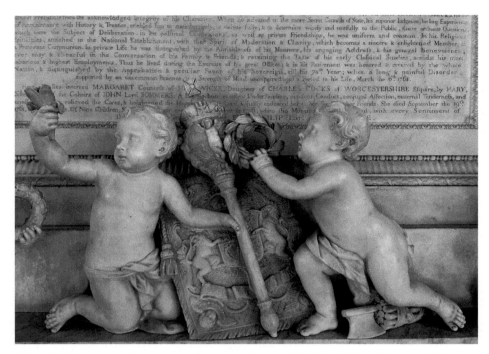

Wimpole. Here we see the ceremonial purse and mace of the Lord Chancellor, carved by Peter Scheemakers in the 1760s.

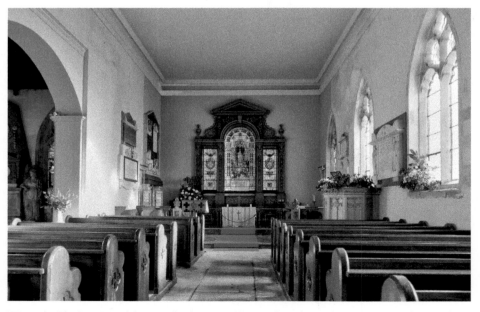

Wimpole. The interior of the nave looking east. A complete classical nave given Gothic windows in the south wall in the nineteenth century.

Hardwicke (d. 1834) by Richard Westmacott Junior (see also Dullingham). The detail of his uniform, honours and the cover of the bible he is supporting is of the highest quality.

45. WISTOW, ST JOHN THE BAPTIST

There must have been a Norman church here as two fragments of sculpture just inside the south door are of that period, but the building we see today dates from the fourteenth and fifteenth centuries. The plan is of a west tower, aisle, nave and a chancel which records tell us was consecrated in 1347. The chancel has a charming sedilia of just two seats that dates from that rebuilding. Sitting in it are two hourglasses which must be the sole surviving fragments from a grand seventeenth- or eighteenth-century monument. The church has two surviving screens. Now set under the tower arch is the spindly remnant of the rood screen, whilst in the south aisle a delightful parclose screen is of a more elaborate design.

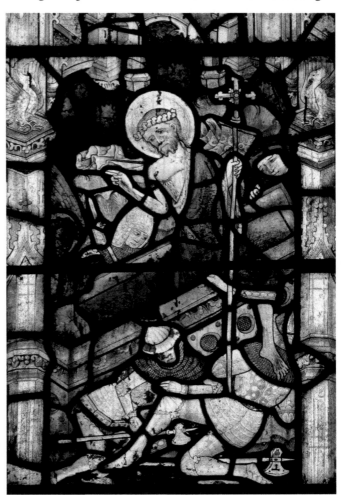

Wistow. One of the finest medieval stained-glass windows in a Cambridgeshire church, showing Christ rising from the tomb.

Whilst it is now entered from the west, the original doorway was in the north side where two of the single openings have been replaced by a glorious two-bay ogee-headed arch. Entrance to the rood loft staircase is in the north aisle and the upper doorway is prominent high in the nave, where it is also possible to pick out the remains of a Victorian text around the chancel arch. In an area known for its elaborate roofs, the nave roof has often been overlooked but retains carved figures on the wall posts and roof itself. The main reason for coming here, however, is to see the medieval stained glass now in the west window of the south aisle, moved from the chancel in 1876. The Annunciation shows Mary being brought the Holy Spirit by an eagle which has a delicately painted face whilst his two colleagues standing on pillars either side are obviously unhappy at not being chosen for the task. Next to this panel is the Resurrection of Christ, where Christ displays his wounds whilst climbing out of the tomb, using one of the sleeping guards as a means of exit. Whilst the soldiers wear similar armour, one set is far more delicately decorated, so may have been painted by a separate hand. Unlike much surviving medieval glass this is displayed at a level where we are able to appreciate the detail.

46. WITCHAM, ST MARTIN

On what must be the quietest High Street in the county, St Martin's doesn't at first glance look particularly interesting, and you'll have to go and collect the key to experience its treasures. The building is mainly thirteenth and fourteenth century in date, as can best be seen in the arcades, both of which were added to an earlier church. It's interesting to compare the two for, although they appear to be identical at first glance, that on the south side is much lower, and earlier. The chancel arch is later again and contains the remains of a medieval screen and loft. To the south of the arch is the first of the treasures here – a stone pulpit. This part of England is known for its wooden pulpits, so this great chunk of medieval masonry comes as a great surprise. No doubt it was originally brightly painted with images of saints beneath its cusped arches. If you ascend its original steps, you'll see that the upper edge has been absolutely covered by graffiti, mostly of the seventeenth century, although some may be earlier. Such a smooth surface proved too much of a temptation to former Witchamites! The pulpit is joined by a low wall to the first pier of the south arcade. Here we can see the first seating in the church, for the base of the pier is enlarged to form an octagonal stone bench, which would have been the only place to rest oneself before wooden benches became commonplace – hence the expression 'the weak go to the wall'.

The one thing the visitor remembers from this church is the font. Everyone has their own ideas as to how old it is. By its shape it should be fourteenth century, but it carries some low relief designs that anywhere else in the country would be dated to the Norman period. Possibly it's something of a hybrid? If indeed it is as late as 1300 then the designs have been inspired by earlier work, possibly even Scandinavian. There are some wonderful dragons alongside an obviously fourteenth-century angel swinging a thurible. The church floors are uneven and incorporate some rather nice octagonal tiles, and there are medieval bench ends at the back. All in all, it is a rustic church with little to jar – apart, that is, from the rather enigmatic east window of the north aisle, which I will leave you to discover for yourself.